RIE MUÑOZ

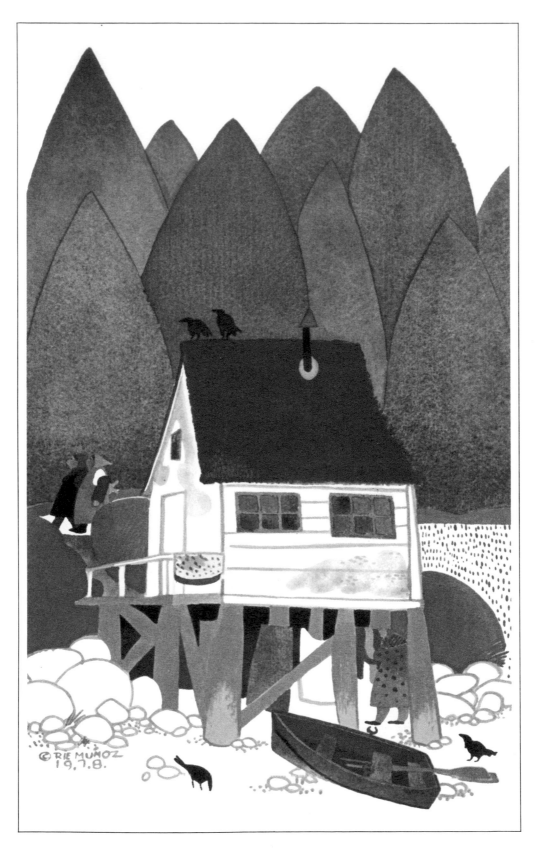

HANGING LAUNDRY, ANGOON
1978
10½ by 16 inches
Water base

RIE MUÑOZ
ALASKAN ARTIST

Introduction by Judy Shuler

ALASKA NORTHWEST PUBLISHING COMPANY
Anchorage, Alaska

Front cover: *Seagull Story* by Rie Muñoz. See page 73 for another reproduction of this water base work completed in 1983.

Back cover: *Gathering Wild Raspberries, Unalaska* by Rie Muñoz. See page 68 for another reproduction of this water base work completed in 1983.

Page 74: Figure taken from *Whale Dance* by Rie Muñoz. See page 54 for a reproduction of this stone lithograph completed in 1981.

Christopher Arend took 70 color photographs of the individual works of Rie Muñoz completed from 1971 to 1980. Staff photographers worked with more recent work to prepare this book.

ISBN-0-88240-257-9

Designer: Cathy Cullinane Skraba

Alaska Northwest Publishing Company
Box 4-EEE, Anchorage, Alaska 99509

Printed in U.S.A.

Introduction

It was a sunny January day in southeastern Alaska, the first day brightened by sunshine in weeks.

In Gastineau Channel, a sometimes turbulent ribbon of the Pacific Ocean that separates Juneau from Douglas, herds of sea lions alternately feasted on herring beneath the waters and surfaced in the sun. Sharing their waters and their taste for herring were a duo of humpback whales.

"What made it so nifty," says Juneau artist Rie Muñoz, "was that it was right in town. All these state workers looked out their windows. Where else could you see government workers passing memos and watching whales and sea lions? I had to put it all together in a painting."

For Muñoz, watching Alaskans and interpreting their activities in light-hearted form is all-consuming. The stately but static mountains and landscapes favored by so many Alaska artists are not for her. Muñoz's world is one of animated movement. Ducks bob on water, cranes scatter through the skies. But most often, there are people: Eskimo women picking berries, fishermen tending nets, villagers going about their lives.

Nor is stark realism her style. Color and form suggest rather than mirror. At one time she painted in white against a blue sky the gulls that are inseparable from the sea. Now she draws them as a blue outline on the blue background.

"I finally figured it doesn't matter if the birds are blue or white."

Small human figures have sported orange and green faces, and movements beyond the reach of any contortionist. But like many artists, Muñoz nudges our way of looking at things. She gently reminds us that things are not always as they first appear, not in life, and not in her paintings.

"You can tell Rie's paintings — they always have a lot of smiling people," someone once said. But that's not true, Muñoz maintains. Very few of her subjects actually smile, but they do exude a sunny, upbeat feeling.

When Muñoz painted a summer fish camp she placed the tents in a cluster. In reality the tents were pitched in a line, but their occupants did so much visiting back and forth from tent to tent that a cluster gave more of a sense of how it felt to be there.

Instead of portraying as a camera might, "I try to get the spirit," she explains.

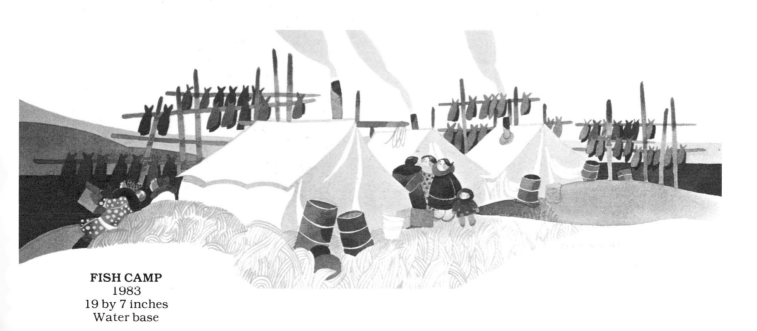

FISH CAMP
1983
19 by 7 inches
Water base

She took similar license painting Eskimos ice fishing at King Island, the arctic community in which she taught school in 1951 and 1952. King Islanders fish some distance from the village itself, but close enough so that the air is filled with the sounds of dogs and children. The sense of proximity takes form on her watercolor paper, with hillside village shacks looming directly behind the fishing holes.

Though her figures have an almost cartoon quality, they are done with deep respect for her subjects. "I don't feel I can walk in and say 'here I am,'" she says, adding that too many villagers are already inundated with state officials on business or other outsiders. She is more comfortable when she can share with a villager something special.

In 1964 Muñoz took a clothesline art show along the road system of the state, stringing the line in towns and villages and hanging it with about 90 paintings and prints by Juneau artists. Artist friends joined her for portions of the journey, sketching as they traveled. Eight years later, with a grant from the Alaska State Council on the Arts, she took a clothesline show to communities along the Bering Sea. Far from highways, she traveled by bush plane and fish tender to take her traveling art show to Nome, Unalakleet, Shaktoolik, Golovin, Shishmaref, Wales, Teller, Gambell and Savoonga.

Rie Muñoz and Alaska discovered their mutual affinity in 1950, nearly a decade before the northern territory was accorded the status of statehood. She was living in Los Angeles, decorating windows in the Broadway Department Store. When vacation time came, Muñoz looked at a map and drew a radius about the size of her cash in hand. The most intriguing point intersected by the circle was Juneau, Alaska.

In Vancouver, British Columbia, she boarded the *Princess Louise,* a tour boat that sailed southeastern Alaska's inland waters. The *Princess Louise* docked in Juneau on a sunny day in June and Rie was captivated. On impulse she disembarked to look for work. If her search

failed, she could reboard two days later as the ship headed south.

The *Louise* sailed without her. Rie found housing on the first day, a job as reporter for the *Alaska Sunday Press* on the second. Juneau has remained her home.

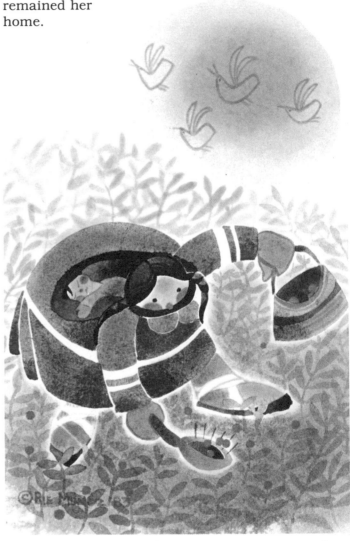

BERRY PICKING
1983
6¼ by 8½ inches
Water base

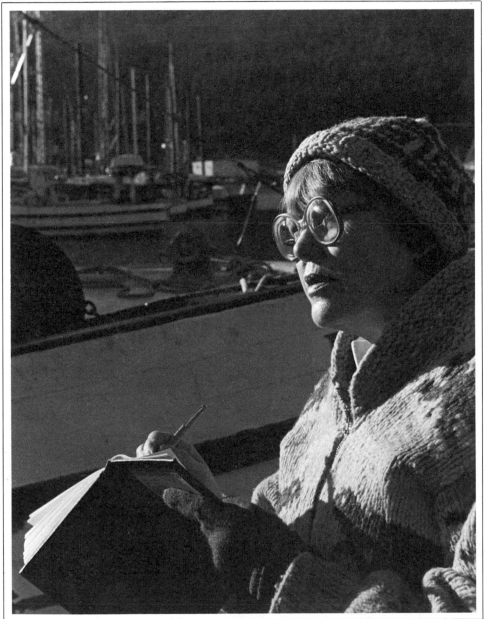

Judy Shuler

Sketching in her field notebook, Rie Muñoz wanders along Juneau's crowded waterfront. A Dutch-American raised in both countries, she has an unpretentiousness about her that fits well with Alaska's relaxed lifestyle. Another artist once struck up a conversation after recognizing her by the patterned wool sweater she has worn everywhere for years.

In 1968 Muñoz bought a house on historic Starr Hill, hugging Mount Roberts and overlooking downtown Juneau and the Gastineau Channel. Starr Hill is just a few blocks from the core of Juneau, blocks that feel more vertical than horizontal. On some winter days the snow that falls on Starr Hill melts to rain before it reaches the downtown streets.

A hiking trail up 3,819-foot Mount Roberts begins with a wooden stairway just two blocks from Rie's house. Another nearby trail was once used by miners en route to the Alaska-Juneau Gold Mining Company mill on the side of Mount Roberts. Remnants of the mill are still visible on the mountain side south of town.

Rie is perhaps fondest of her occasional autumn neighbors, the black bears which have wandered down to her yard in years past and loitered for a few weeks. Twice she has had to cancel dinner invitations because a blackie stubbornly remained 15 feet from her door.

In the summer of 1980, while Juneau was celebrating its first one hundred years, Rie was remodeling the second story of her house as an artist's studio, with glass dormer, clerestory windows, and hardened pine floor. The studio has a tiny loft, a bright emerald green ceramic wood stove made in Italy, and lemon canvas director's chairs. Cabinets built beneath the eaves hold paints and supplies and a recent indulgence, a black-and-white television set.

She paints at a small table that sits beneath the glass dormer, gathering light from the south and west. Her tubes of watercolor, casein, and acrylic paints are nearby in a cabinet on wheels. When she is not traveling, Muñoz spends at least four hours a day painting in her studio.

KOTZEBUE BREAKUP
1977
28¼ by 10 inches
Water base

Shows are scheduled a year or more in advance, though she resists fixed goals in terms of output.

"A certain amount of pressure is good," she says, but "if you put on too much pressure your work can suffer."

She estimates that for each painting she produces one is consigned to the nearby wastebasket. Sometimes she will reuse the back of the paper. Owners of her carefully framed work might discover a reject on the reverse side.

"When I haven't painted for a while I can paint two weeks without doing anything that I like," she says. "You just have to keep painting." Painting gives her such pleasure she denies it requires discipline.

Muñoz consciously turns her attention away from activities and issues that threaten to divert time from work.

"I think when you get upset over political or other issues you should do something about it, which takes a lot of time. You have to set priorities and painting is mine."

Thus the cause of conservation, which has her sympathy, gets a generous check instead of her time. However, she does interrupt her painting willingly to retrieve a ball for Buddy Pierre, a part Labrador-some St. Bernard, who acquired the second half of his name when a friend deemed him too elegant for a common name like Buddy.

Though her admirers have little trouble identifying her work, she says, "I have the feeling I'm constantly changing. I know I am, which is good. If my work remained the same, if I quit exploring and growing I'd quit."

Lately her familiar bright colors have been tempered by a greater use of neutrals. Colorful parkas may be set against gray shacks and a brown sky.

Field sketches are "very rough. They do nothing more than record in my mind what I saw so I will be able to recall it."

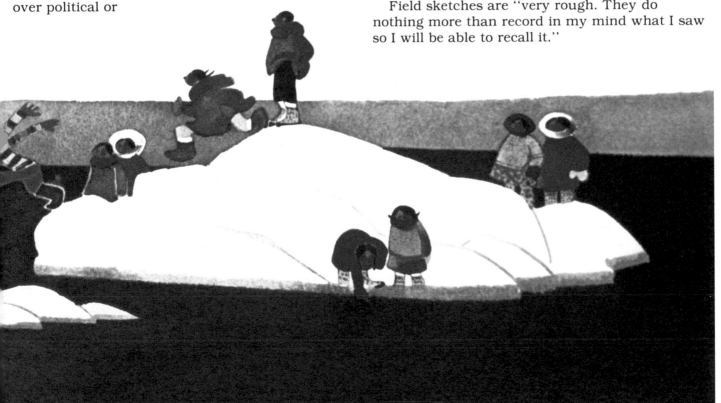

If she is including something mechanical she will also photograph the object for detail. Most sketching sessions occur by plan, not accidentally, although she has resorted to the backs of checks or napkins when an arresting face or scene caught her by surprise. Once she is comfortable with recalling what she has seen, Muñoz says "I take license with just about everything."

What she does in the actual painting, she says, is not done in the traditional watercolor technique. She completely paints the main figures, then settles on the background and lesser details that will convey the desired mood. This approach, developed over the years, works well for her.

She does 70 to 90 paintings each year. All her paintings are handled through a few galleries or special shows, which typically sell out on opening day. One gallery even draws names for the chance to purchase one of her original paintings. Modestly priced photo reproductions of her watercolors also sell rapidly. She does not take orders or sell on the side.

When she was in Paris doing a stone lithograph edition she was struck by a painting translated into a wool tapestry. Rie returned to Juneau with plans for transforming one of her own paintings to fabric. Her 5½-foot by 8½-foot *Creation of Man*, an Eskimo story in shades of lavender, blue and gold, sold immediately and now hangs in the lobby of the Alaska National Bank of the North in Juneau. Three smaller tapestries, *Mermaid Legend, Crane Legend,* and *Whalers Pushing through Baby Ice,* followed. Ten of her paintings have been interpreted in fiber.

She now does tapestries only on order, because of the substantial investment. After the painting is selected, Muñoz takes it to Paris where it is photographed in black and white and enlarged to the exact size of the finished tapestry. The photograph and her original painting then go to a weaving studio in Aubusson, France, where she discusses with weavers the changes that must be made to translate the work from paint to fiber.

A line that appeared straight in the painting, for example, will show wavy imperfections and variations in the greatly enlarged black and white photograph of the art work. Muñoz and the weavers may decide to interpret it to a straight line. In tapestry, a perfect circle is impossible because of the right angle of the threads.

A photograph of the painting is rolled onto the loom with the warp, providing a life-size pattern for the weaver to follow. The original will hang nearby to guide color selection for the yarn.

The actual weaving process may take a month or more per square meter, depending on complexity of the design. Usually it will be done by one weaver working on an ancient hand loom with two treadles.

During Muñoz's trips to Europe she may also work on a stone lithograph in Paris and, of course, tour galleries.

In addition, Muñoz designs silkscreens, which are printed by Serigraphics in Albuquerque, New Mexico. The Megara and Coriander studios in London each printed several editions of her silkscreen prints as well.

Working on a grander scale, Muñoz has painted several murals in Alaska, dating back as far as 1951. Some were lost when buildings burned or were razed or remodeled. Three still exist in Juneau. A tribute to Alaska's various ethnic groups is housed at the Alaska State Library and a mural of the Chilkat Dancers of Haines watches over arriving luggage at Juneau Municipal Airport. A third mural is in Harborview Elementary School, Juneau. The Alaska Council of Churches commissioned her to create a mural of the history of church activities in Alaska; it is located in the library of the University of Alaska in Fairbanks.

She has illustrated *Goodbye, My Island,* a children's book by Juneau author Jean Rogers; *Kahtahah,* a book about a young Tlingit girl at the turn of the century; *The Alaskan Camp Cook; Handbook for the Freshman Legislator;* and many magazine articles. One of her paintings was selected for the month of April in the 1981

calendar, "In Praise of Women Artists." Another was included in the engagement calendar, "1983 — Contemporary Women of America."

In 1977 the Anchorage Historical and Fine Arts Museum Association named Rie Muñoz outstanding Alaskan artist of the year.

Though she remembers sketching horses and elegant ladies when she was not more than six years old, Muñoz has not always been a full-time artist. At the end of World War II, she was a WAC stationed in the Bavarian Alps, working as a German-English interpreter. Later she was a reporter and cartoonist for *Pass-Times,* a biweekly publication put out by the United States Third Army, Garmisch-Partenkirchen, West Germany.

During 1951-52 she taught school on King Island. Following a year of teaching, Muñoz became a reporter and political cartoonist for the *Daily Alaska Empire.*

In 1968 Muñoz became curator of exhibits at the Alaska State Museum, a post she resigned in 1972 to devote all her energies to art. Despite more than three decades in Alaska's capital, she has effectively tuned out the omnipresence of government and of legislators.

Rie Muñoz, a husky-voiced Dutch-American raised in both countries, is unpretentious, with an air of no-nonsense directness. Another Alaska artist once struck up a conversation with her after recognizing the patterned wool sweater she has worn everywhere for years.

There are other paintings haunting the recesses of her mind, seeking a form that will satisfy her. Some ideas verge on what she feels she rarely paints — social commentary. She is mulling ways to depict the pomp of the elected, the mien of a decidedly unhappy woman at happy hour. Juxtaposition of technology and tradition in village Alaska is a recurring theme.

With subjects as mercurial and many-sided as Alaskans to draw upon it is unlikely that Rie Muñoz will ever lack for inspiration.

Judy Shuler
Juneau, 1982

NORTHERN LIGHTS
1982
30 by 68 inches
Tapestry

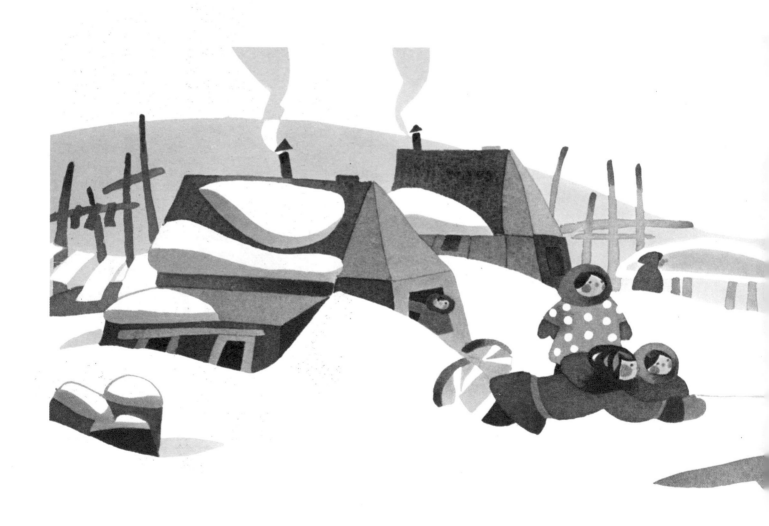

RIE MUÑOZ
ALASKAN ARTIST

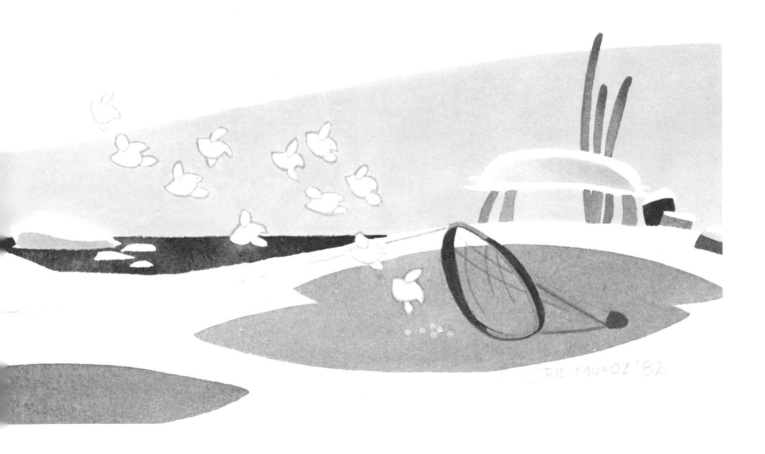

SNOW BUNTING—GAMBELL
1982
22¾ by 8 inches
Water base

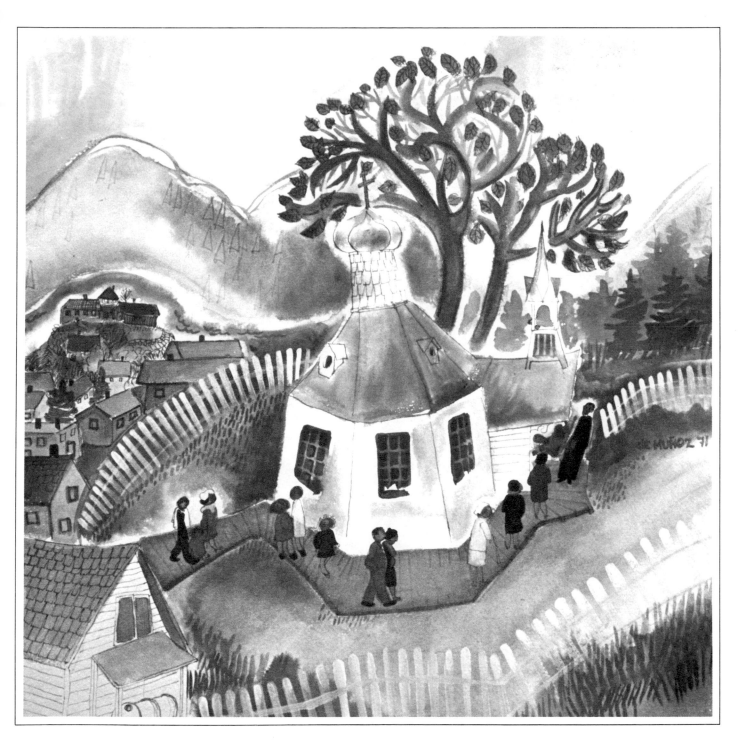

SUNDAY MORNING IN JUNEAU
1971
18½ by 18 inches
Water base

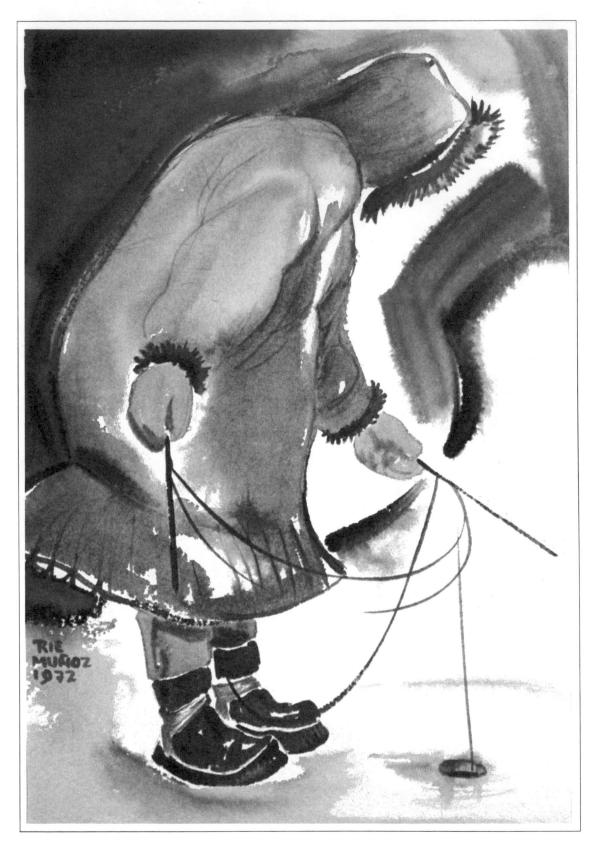

ICE FISHING
1972
9½ by 14 inches
Water base

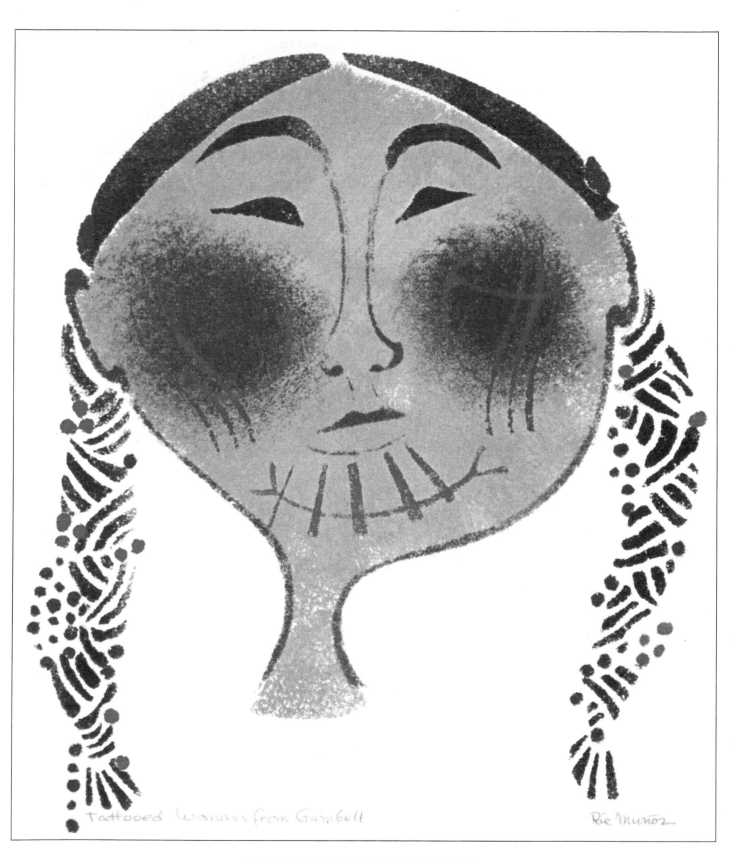

Tattooed Woman from Gambell

Rie Muñoz

TATTOOED WOMAN FROM GAMBELL
1972
10 by 12 inches
Stencil print

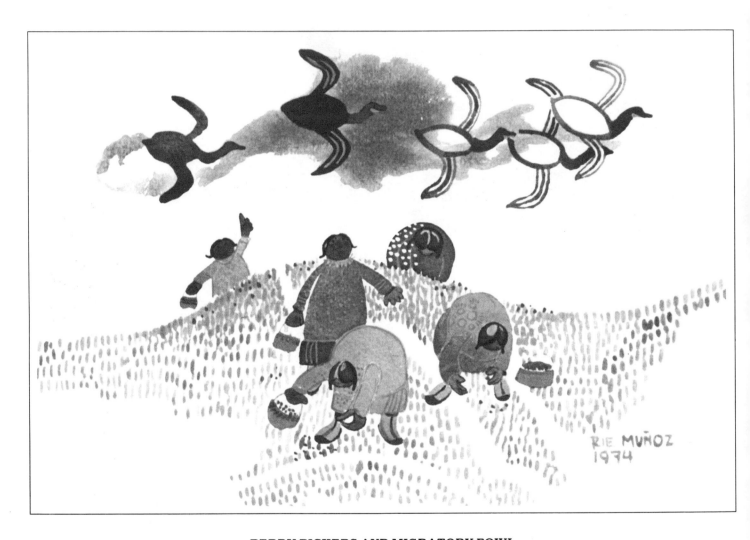

BERRY PICKERS AND MIGRATORY FOWL
1974
12½ by 8½ inches
Water base

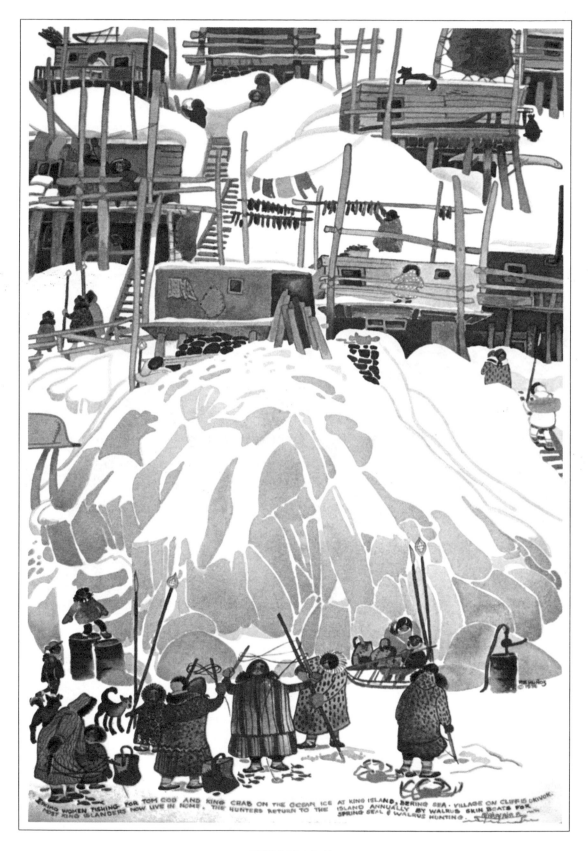

KING ISLAND
1974
15 by 22 inches
Water base

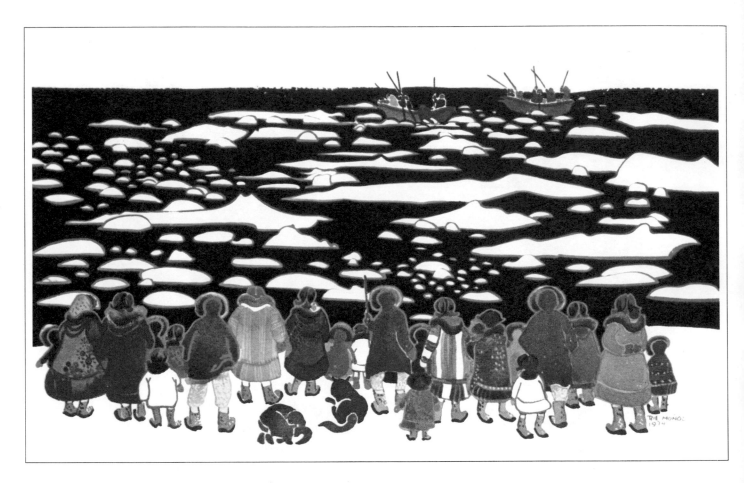

WHALERS PUSHING THROUGH BABY ICE
1974
21 by 12 inches
Water base

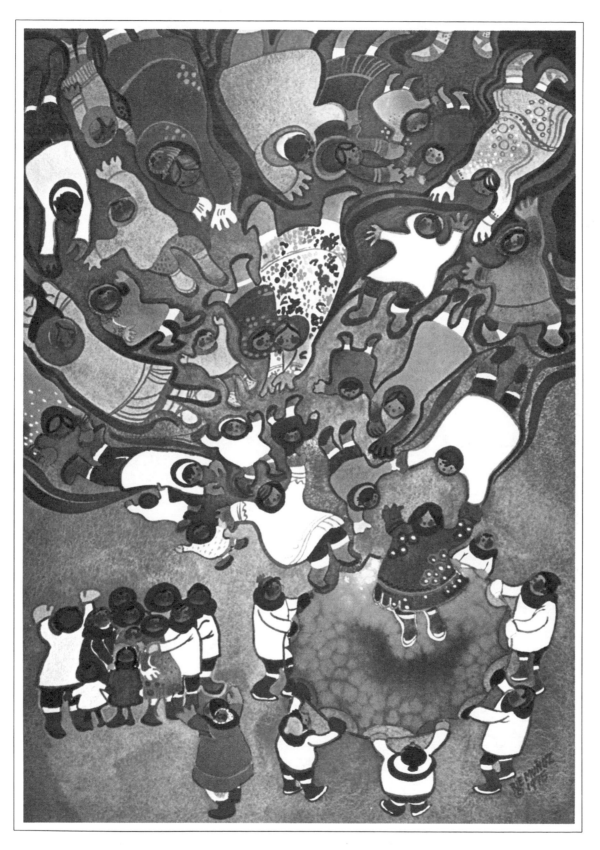

CREATION OF MAN
1975
15 by 22 inches
Water base

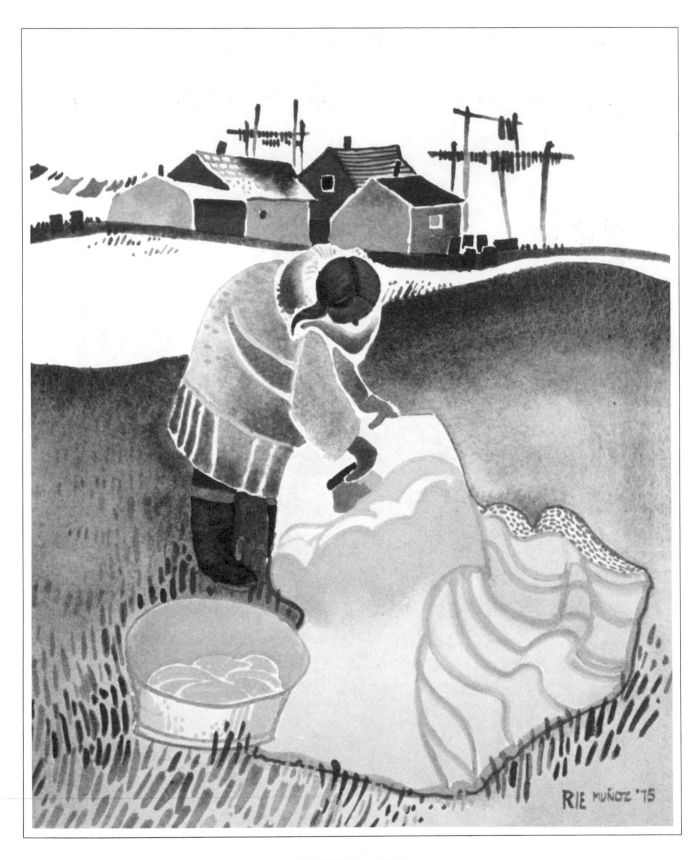

FLESHING A HIDE
1975
10⅜ by 13½ inches
Water base

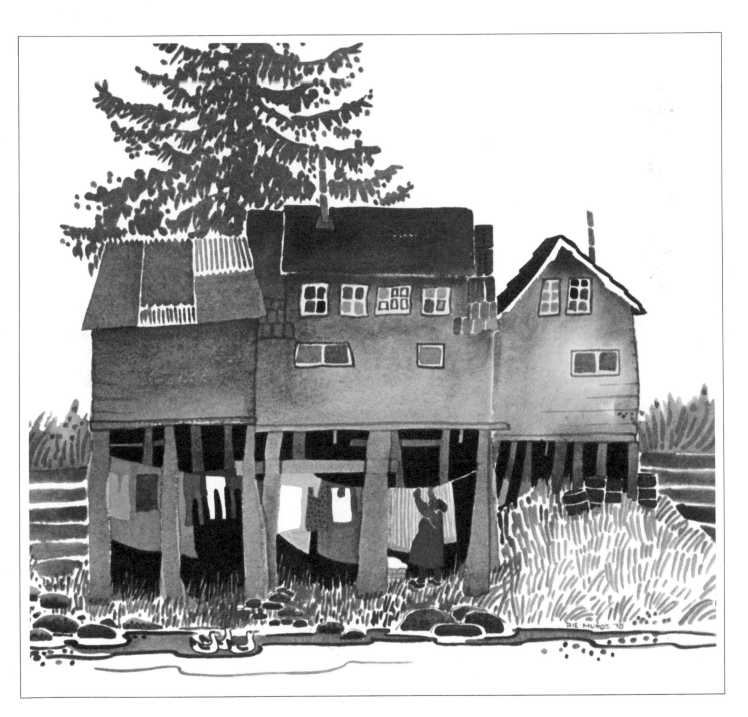

WASHDAY AT ANGOON
1975
17½ by 16¼ inches
Water base

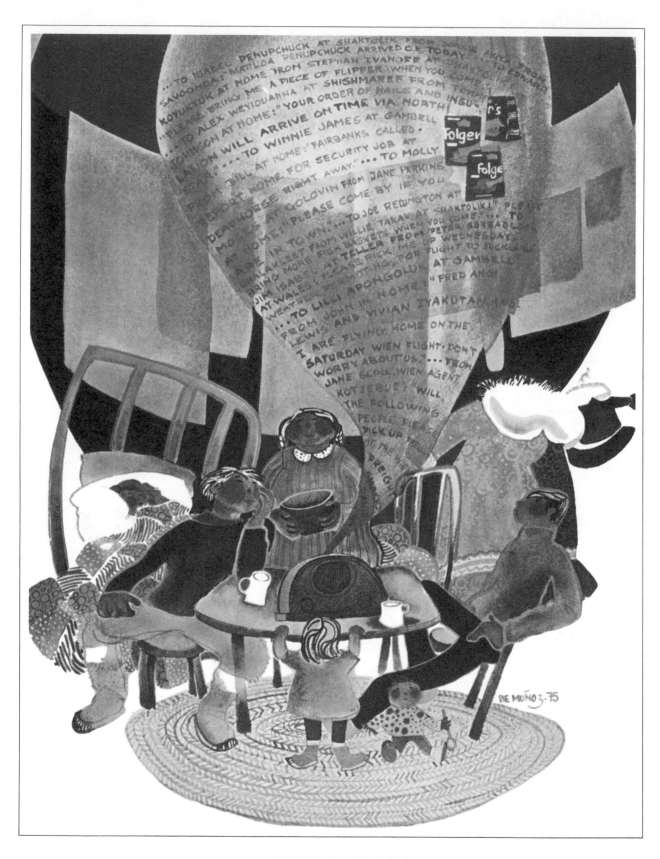

PTARMIGAN TELEGRAPH
1975
13 by 17 inches
Water base

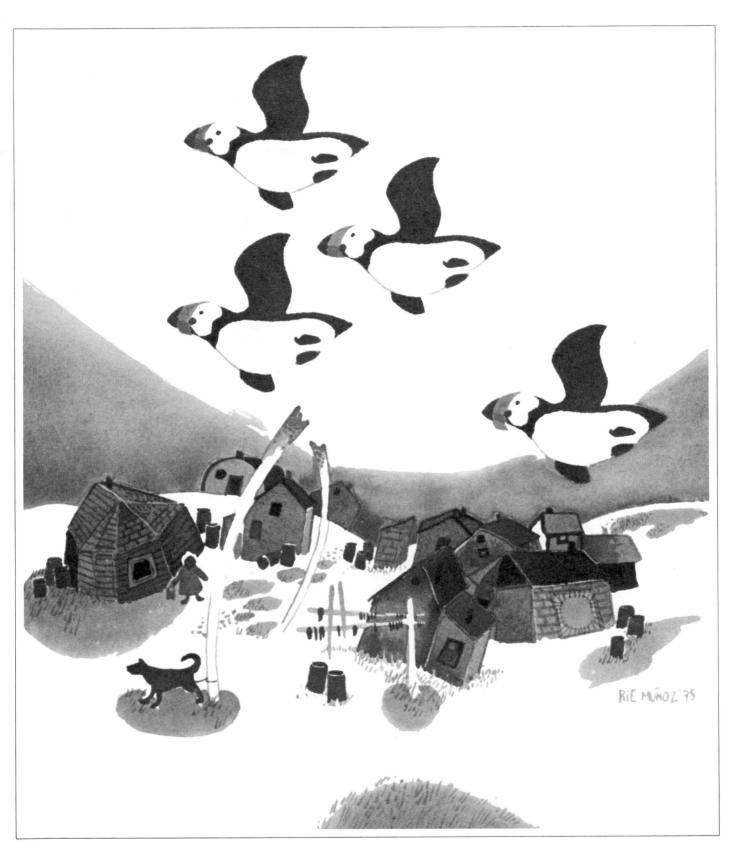

PUFFINS, EARLY SPRING AT GAMBELL
1975
11 by 13 inches
Water base

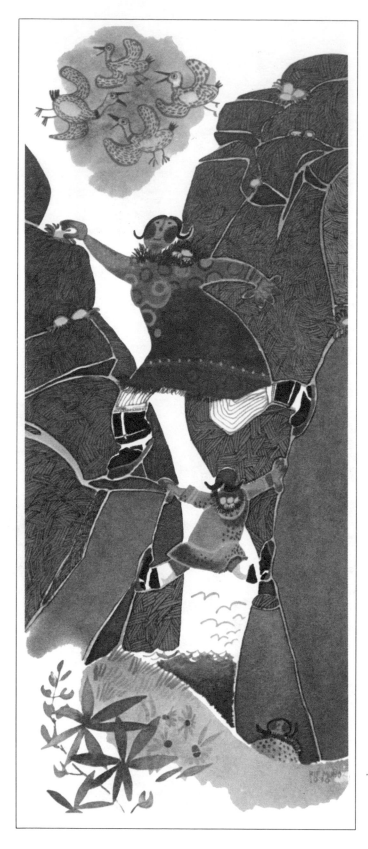

GATHERING EGGS
1976
8 by 19 inches
Water base

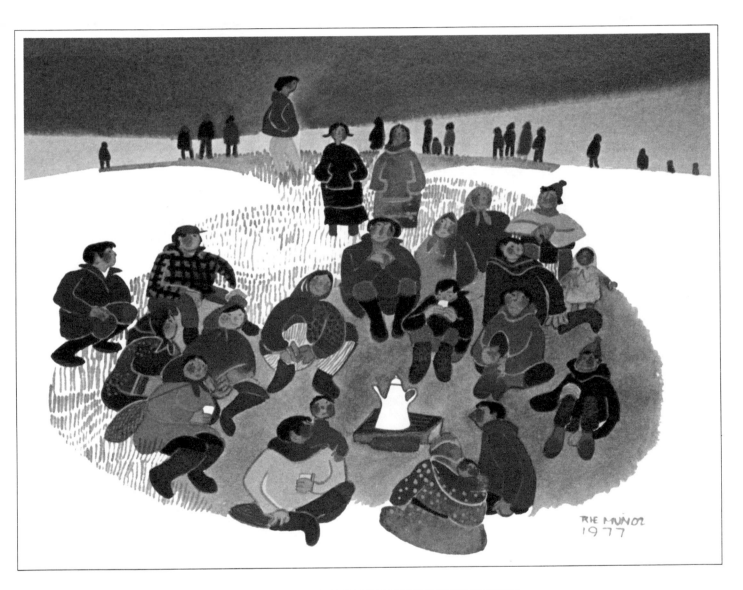

WAITING FOR REINDEER ROUNDUP (NUNIVAK)
1977
11⅝ by 9 inches
Water base

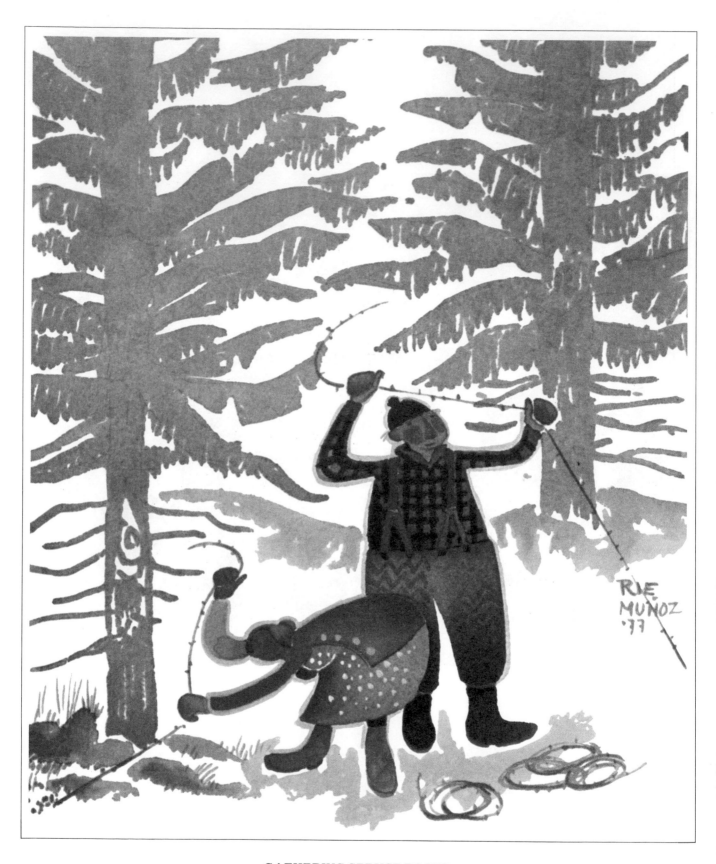

GATHERING SPRUCE ROOTS
1977
8 by 10¼ inches
Water base

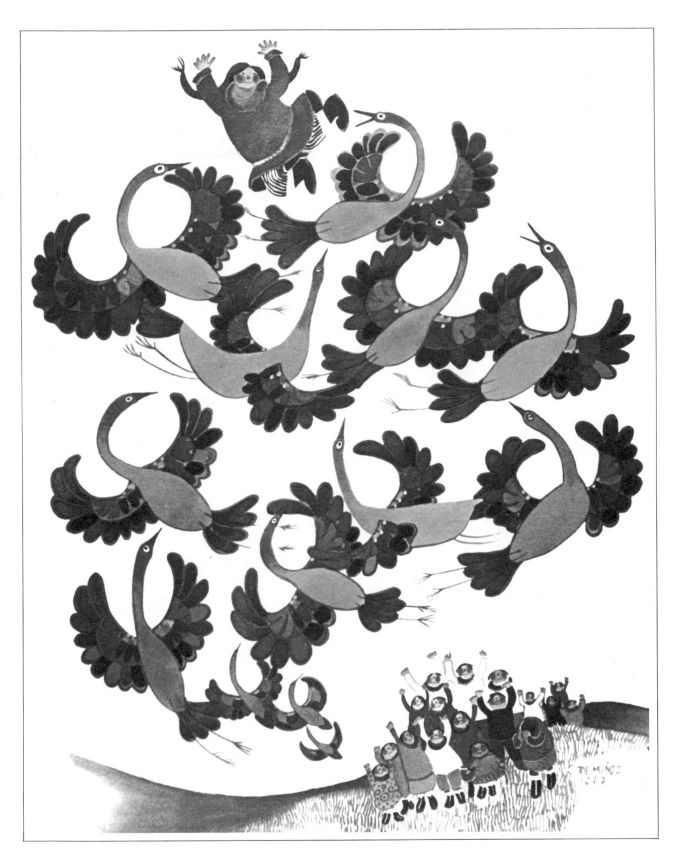

CRANE LEGEND
1977
14½ by 19 inches
Water base

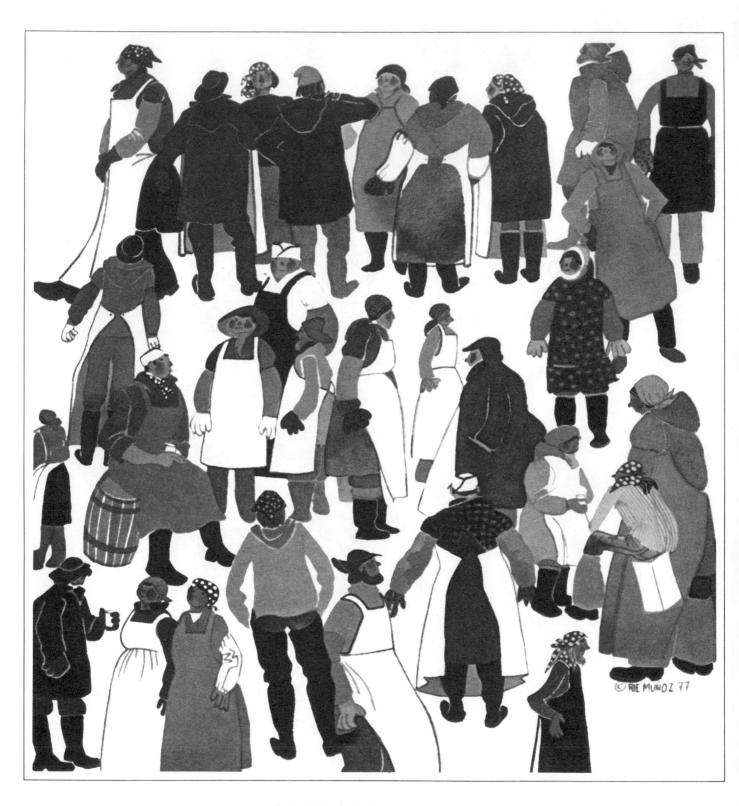

CANNERY WORKERS, NAKNEK
1977
13½ by 14½ inches
Water base

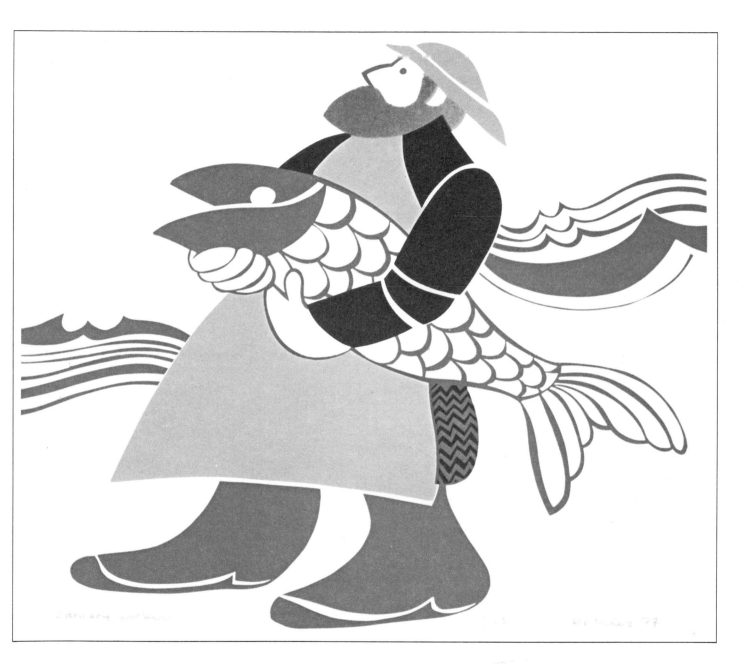

CANNERY WORKER
1977
16½ by 15 inches
Serigraph

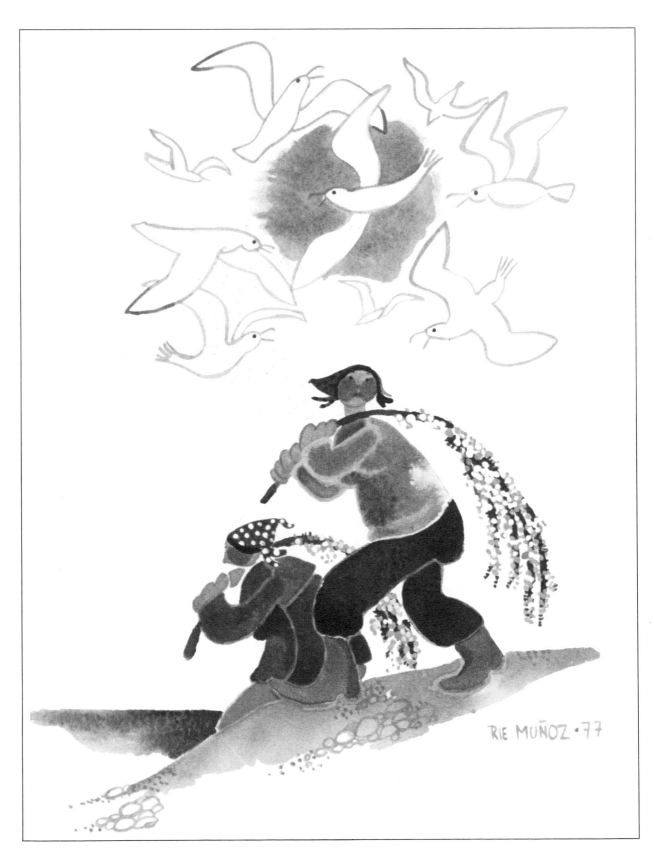

HARVESTING HERRING EGGS
1977
7⅞ by 11⅝ inches
Water base

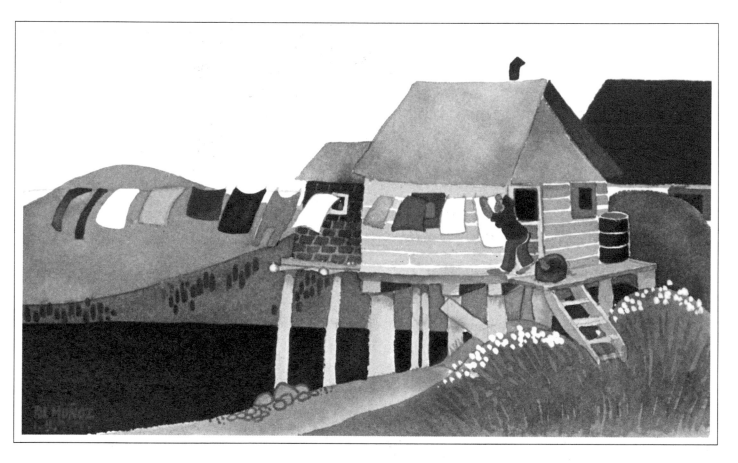

WASHDAY AT TENAKEE
1977
11½ by 6½ inches
Water base

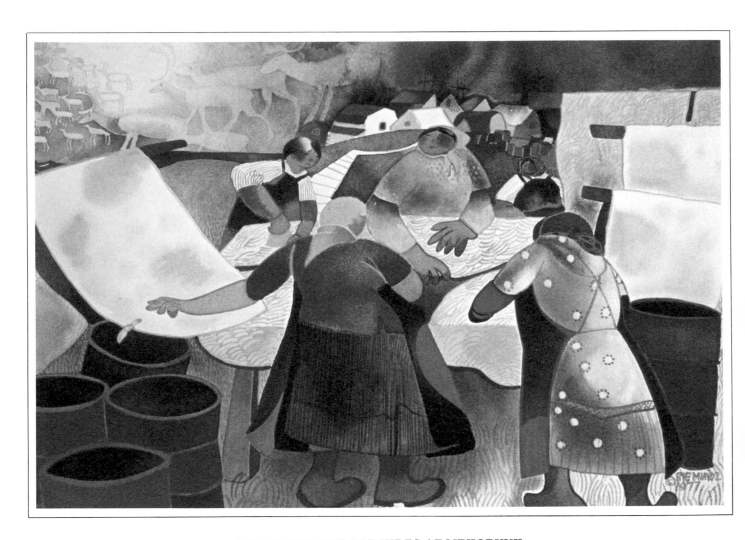

SCRAPING REINDEER HIDES AT MEKORYUK
1977
19½ by 13½ inches
Water base

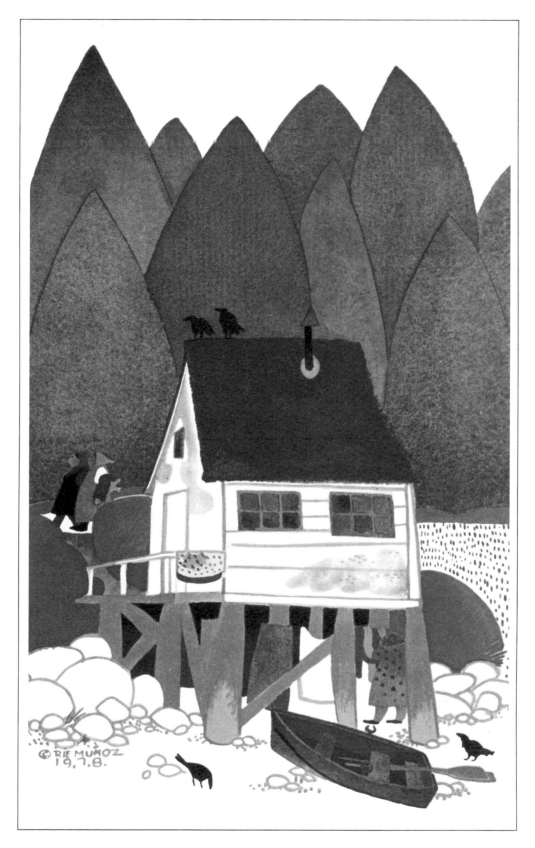

HANGING LAUNDRY, ANGOON
1978
10½ by 16 inches
Water base

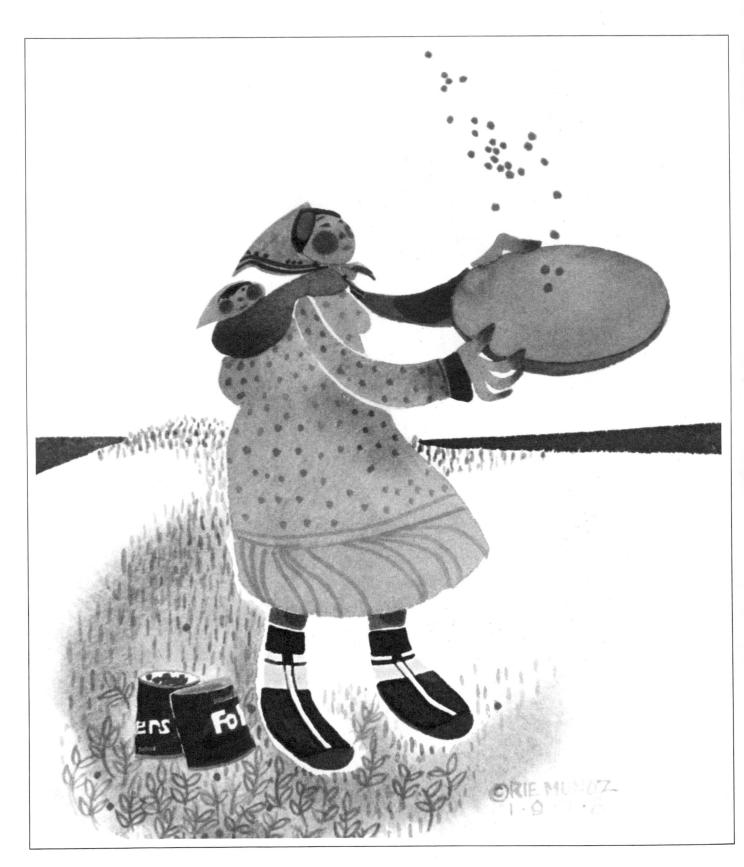

WINNOWING BERRIES
1978
8¼ by 10½ inches
Water base

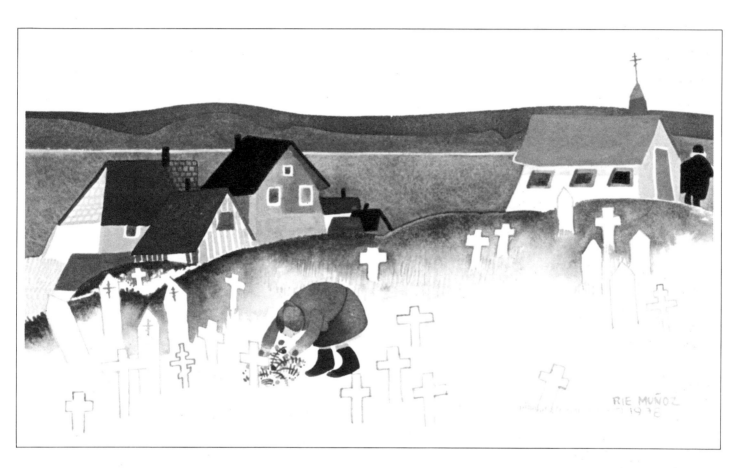

CEMETERY AT NAKNEK
1978
13 by 7⅞ inches
Water base

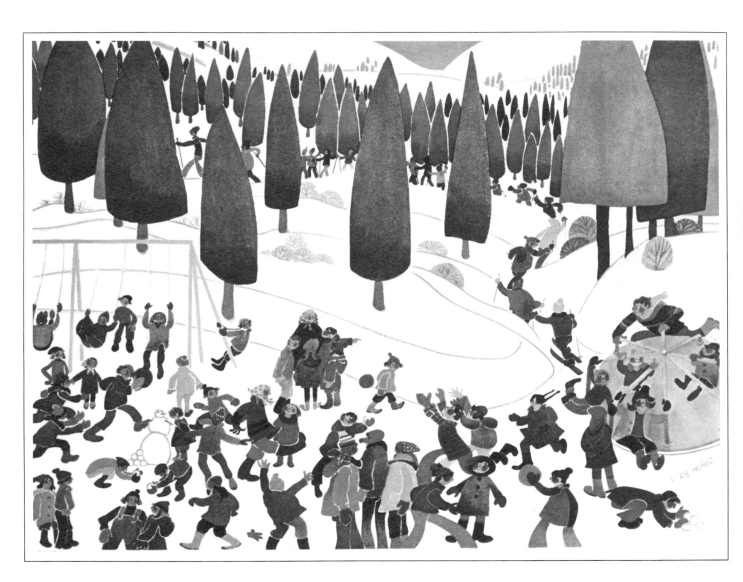

RECESS, AUKE BAY SCHOOL
1978
29¼ by 21¼ inches
Water base

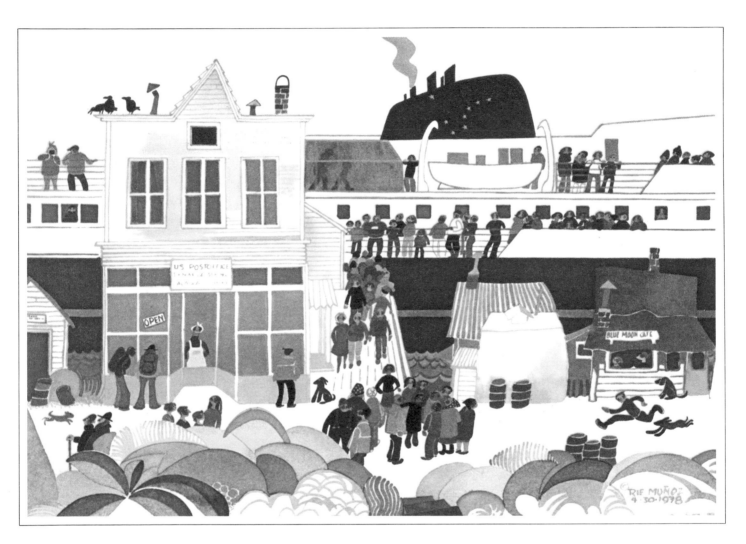

INAUGURAL VOYAGE, TENAKEE
1978
21⅜ by 14½ inches
Water base

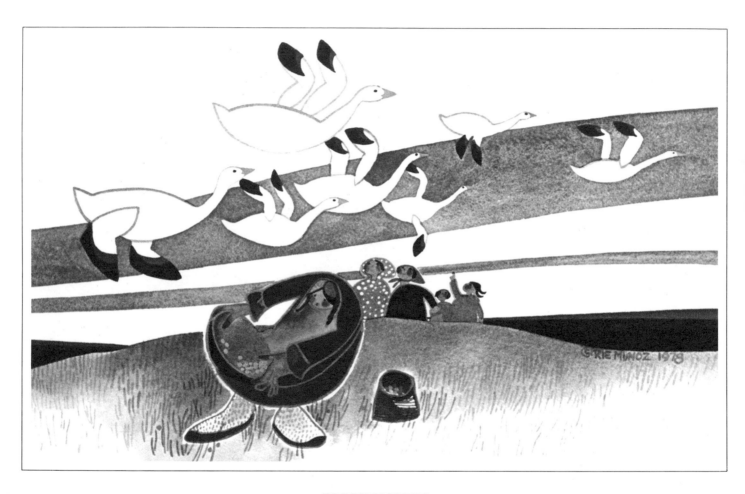

BERRY PICKERS
1978
17½ by 11½ inches
Water base

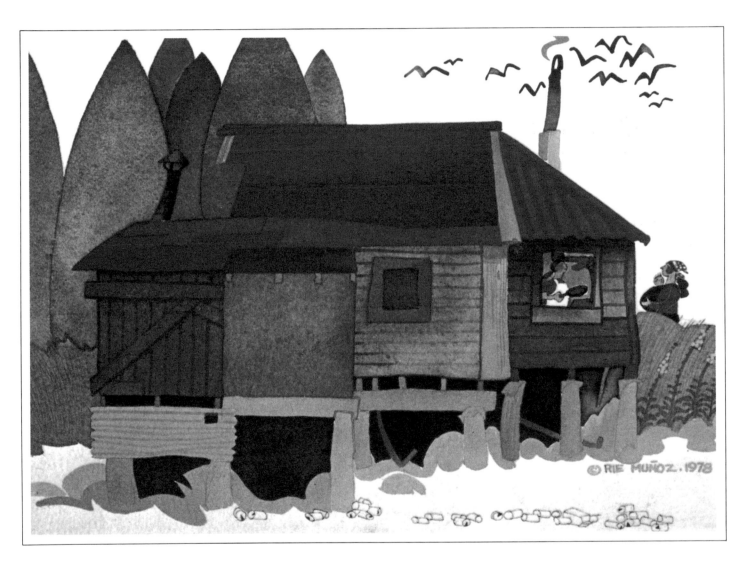

BACK SIDE OF BLUE MOON CAFE
1978
13 by 8½ inches
Water base

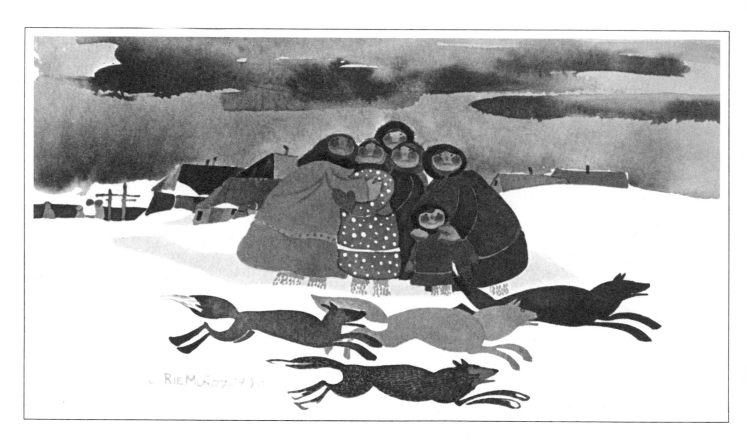

LOOSE DOGS, GAMBELL
1979
12 by 6½ inches
Water base

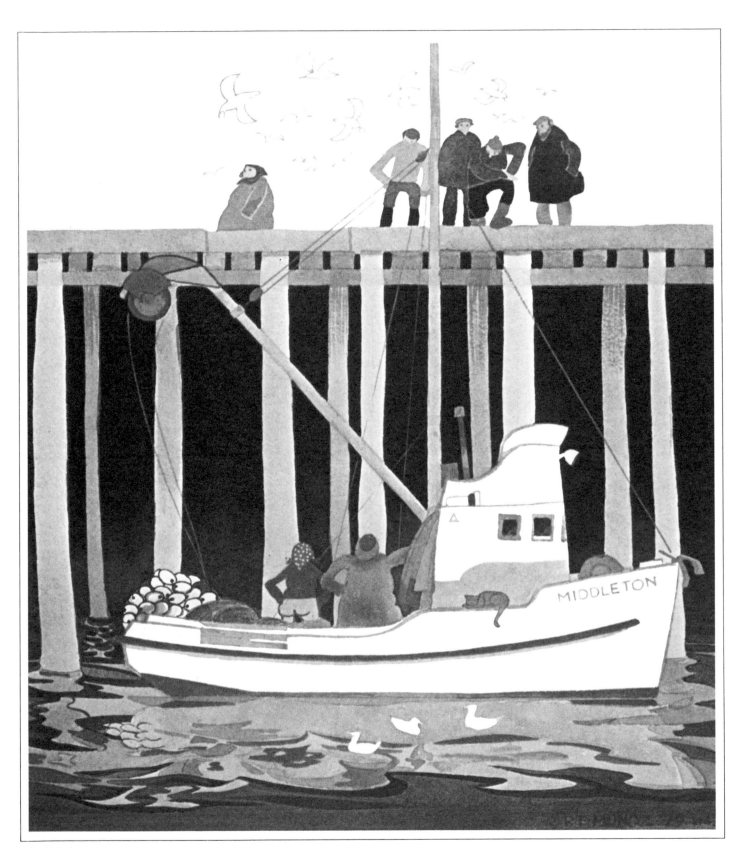

THE MIDDLETON
1979
10½ by 12½ inches
Water base

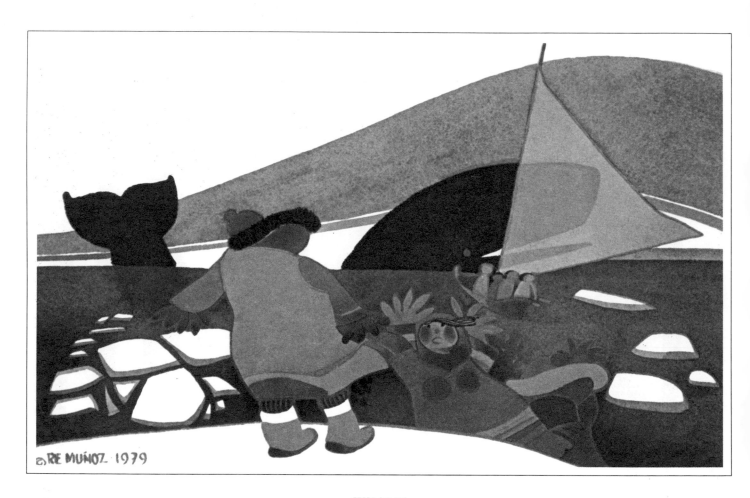

WHALE!
1979
14 by 9½ inches
Water base

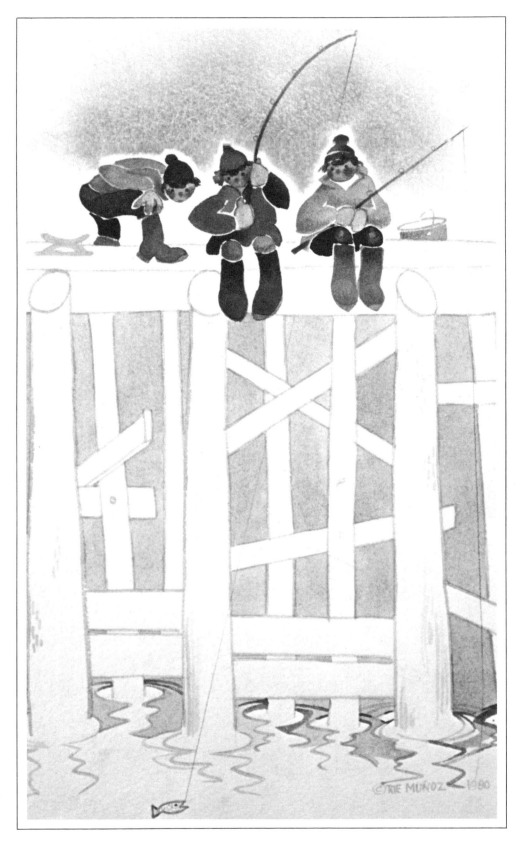

GOOD FISHING
1980
7 by 12½ inches
Water base

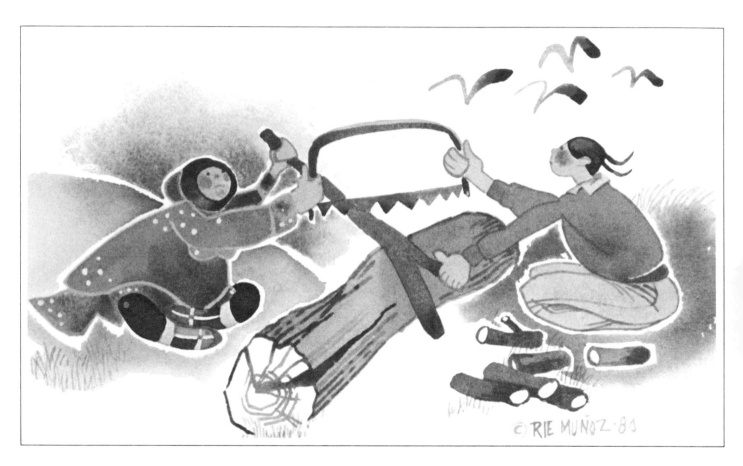

SAWING FIREWOOD, SUMMER CAMP
1980
10¼ by 7 inches
Water base

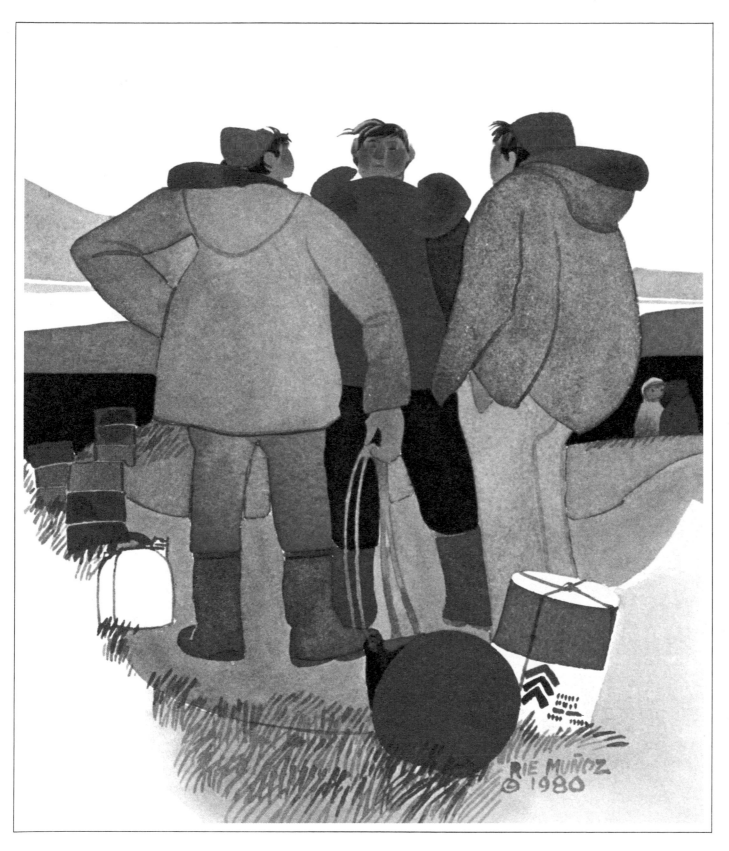

WHALERS AT SUMMER CAMP
1980
9⅜ by 11⅞ inches
Water base

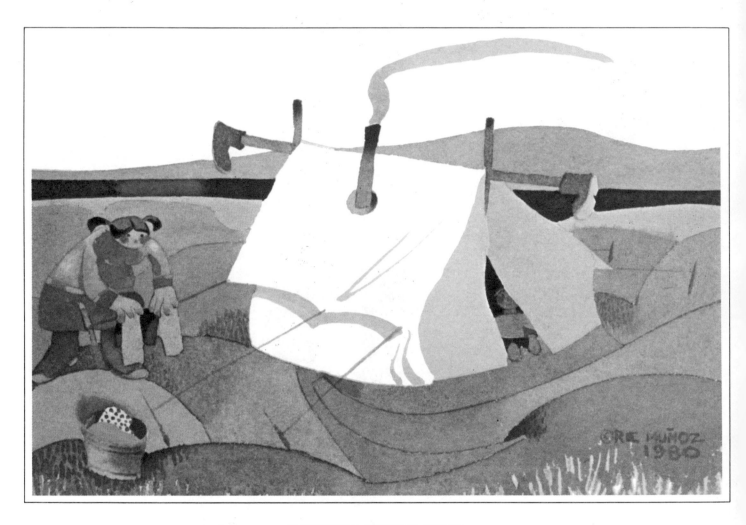

HANGING LAUNDRY, SIGIK
1980
10½ by 7 inches
Water base

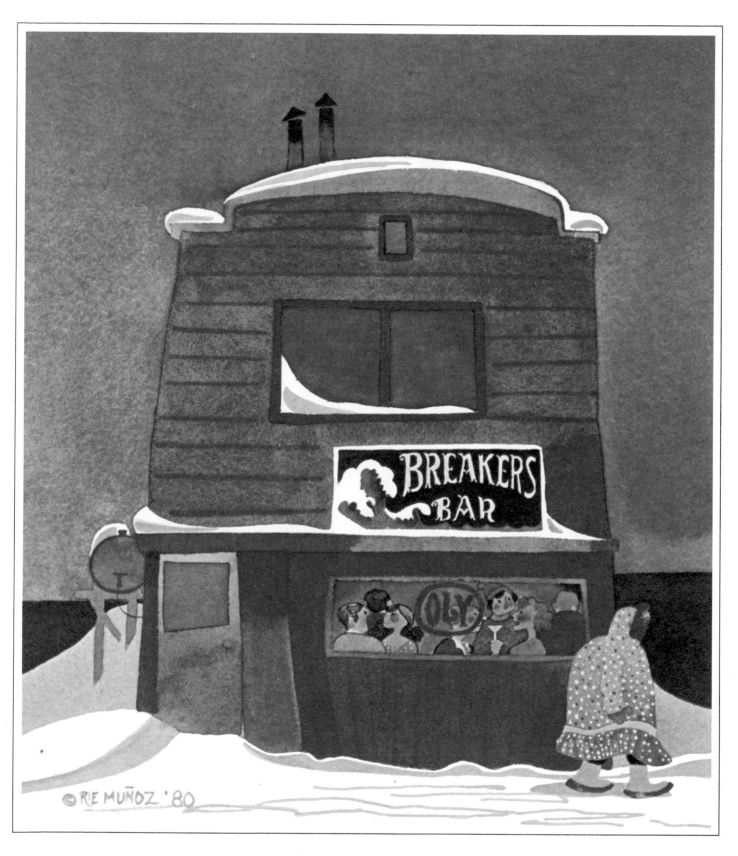

HAPPY HOUR, NOME
1980
10 by 13 inches
Water base

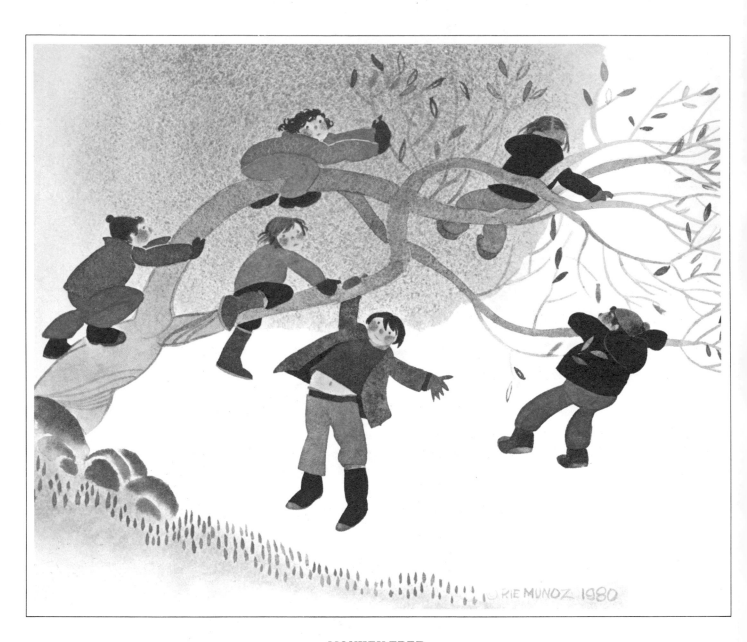

MONKEY TREE
1980
13 by 10¼ inches
Water base

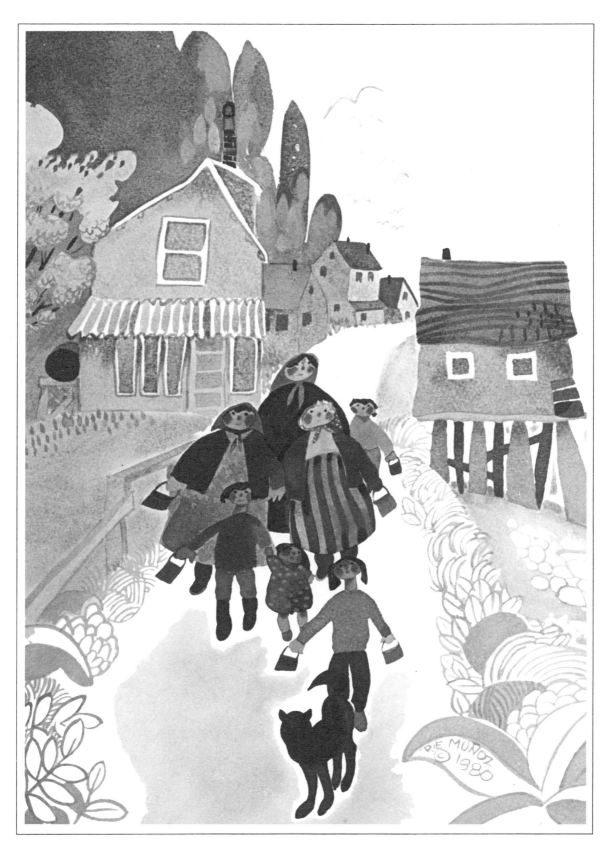

GOING BERRY PICKING, HOONAH
1980
10¼ by 14 inches
Water base

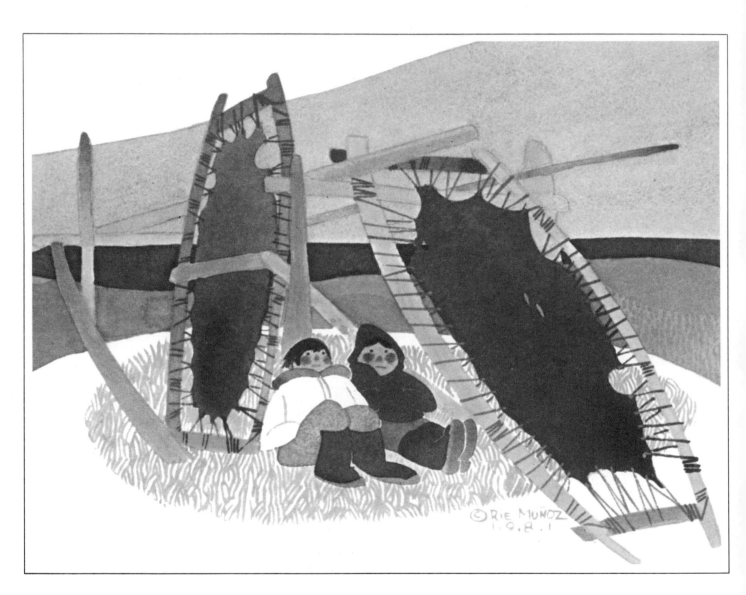

FRIENDS
1981
9¼ by 6¾ inches
Water base

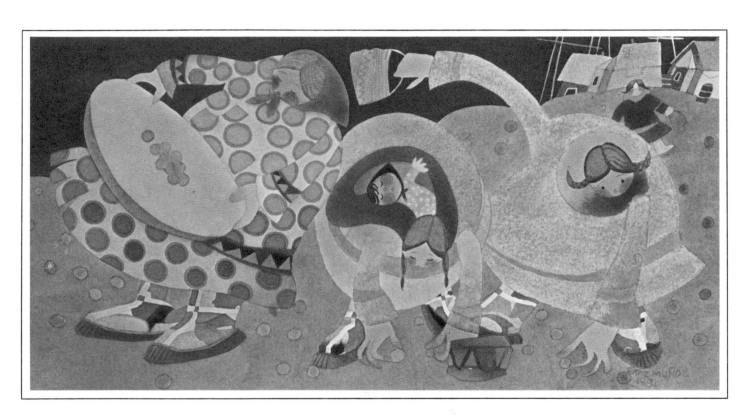

BERRY PICKERS
1981
16¼ by 8¼ inches
Water base

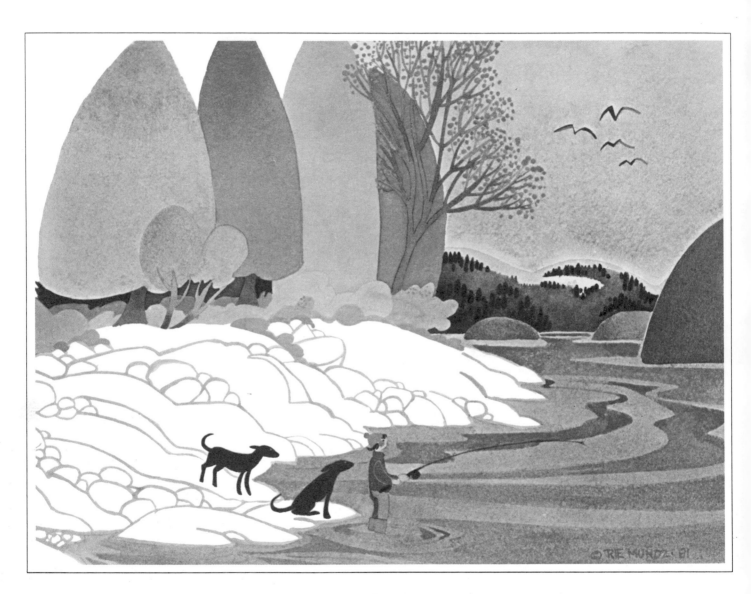

FISHERMAN
1981
14 by 10½ inches
Water base

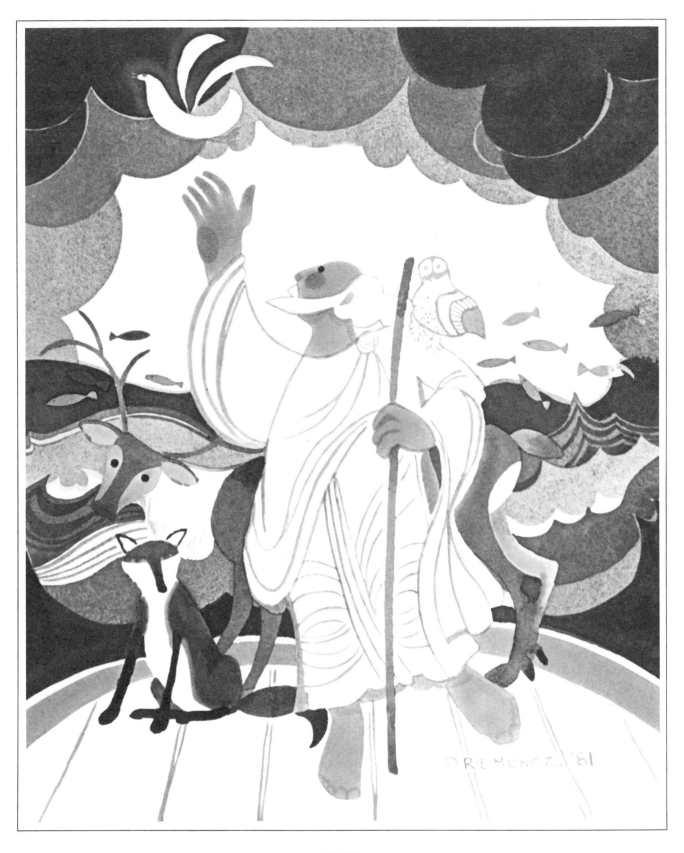

NOAH
1981
11 by 13 inches
Water base

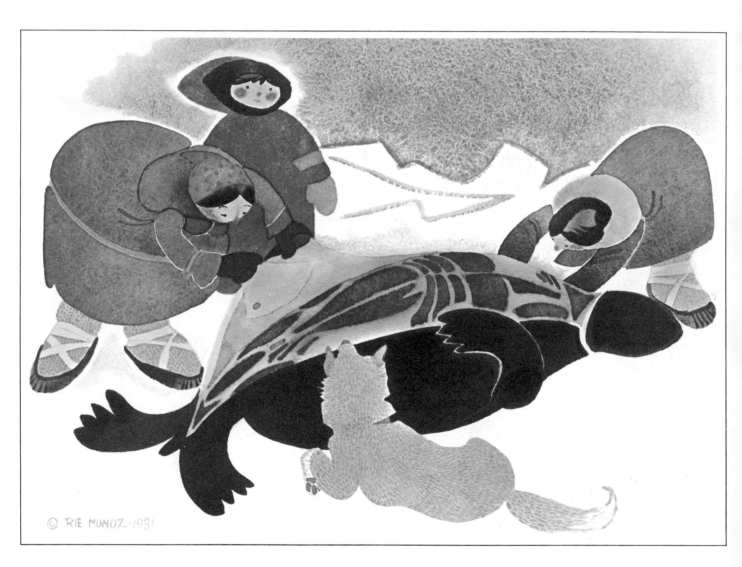

SKINNING AN OOGRUK
1981
11¾ by 9 inches
Water base

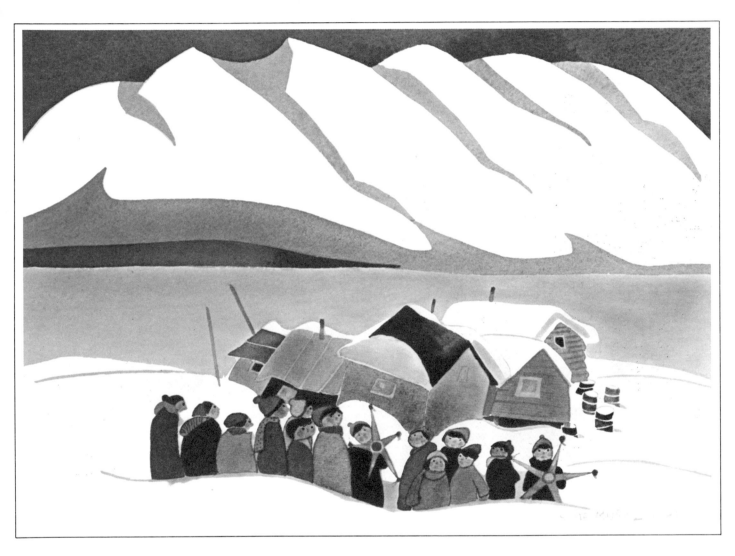

STARRING
1981
11½ by 8¼ inches
Water base

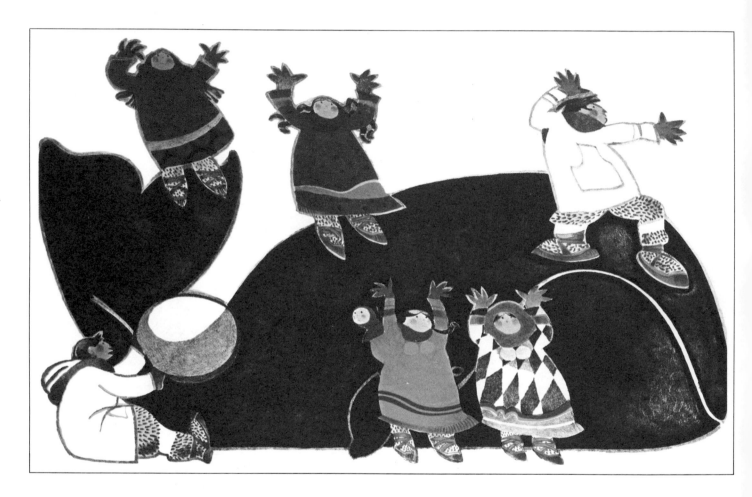

WHALE DANCE
1981
22 by 15 inches
Stone lithograph

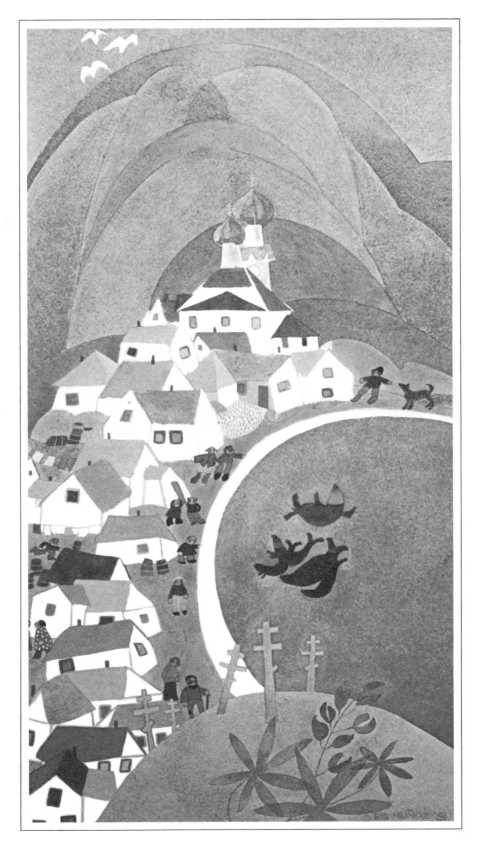

SEA LIONS AT UNALASKA
1981
11¼ by 21 inches
Water base

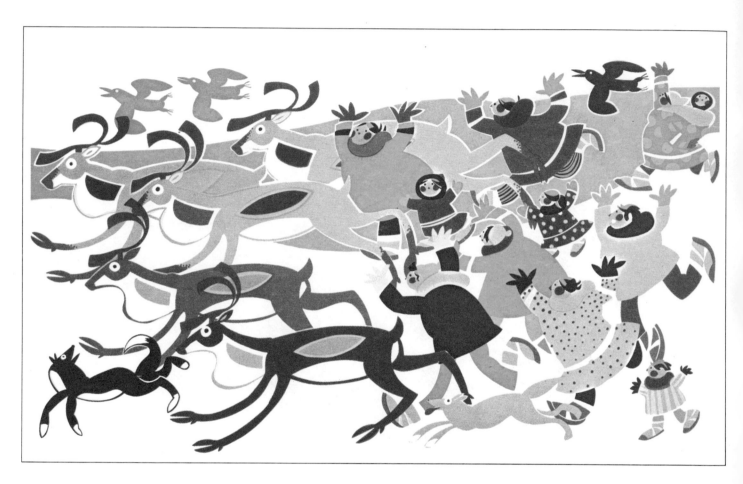

REINDEER ROUNDUP
1981
21½ by 12 inches
Serigraph

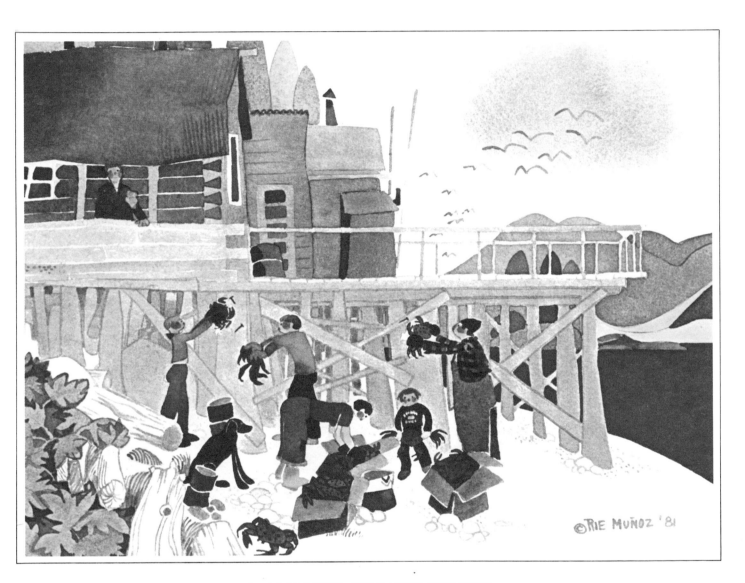

CRAB BUTCHERING PARTY, TENAKEE
1981
13¼ by 9¾ inches
Water base

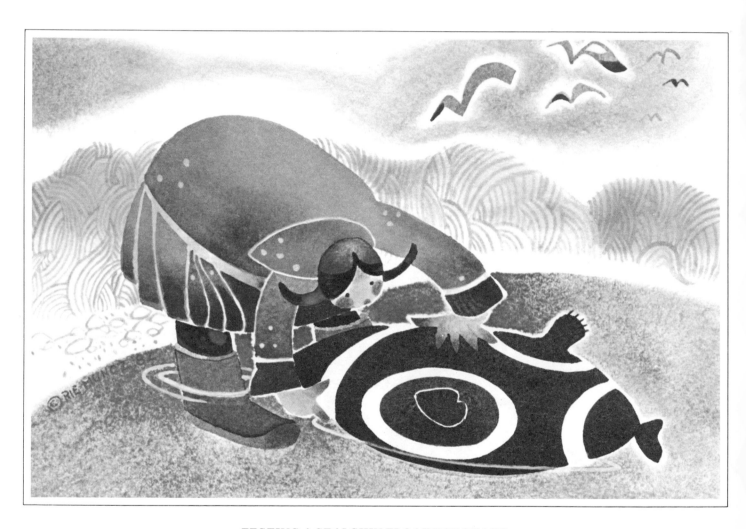

TESTING A SEALSKIN FLOAT FOR LEAKS
1982
12 by 9 inches
Water base

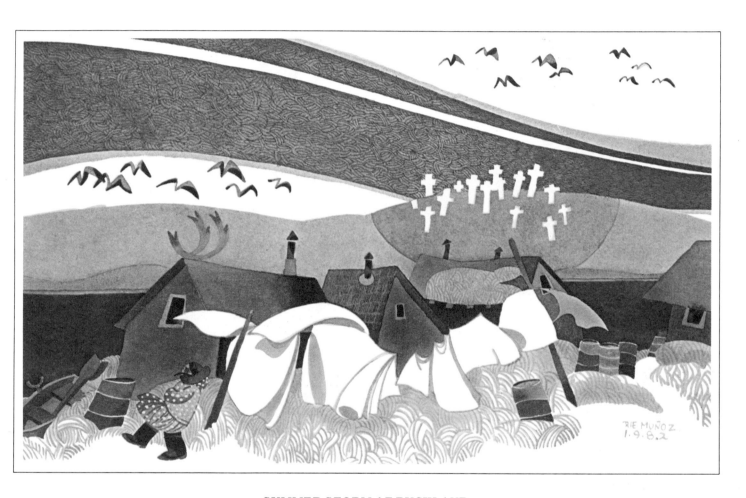

SUMMER STORM AT BUCKLAND
1982
20 by 13 inches
Water base

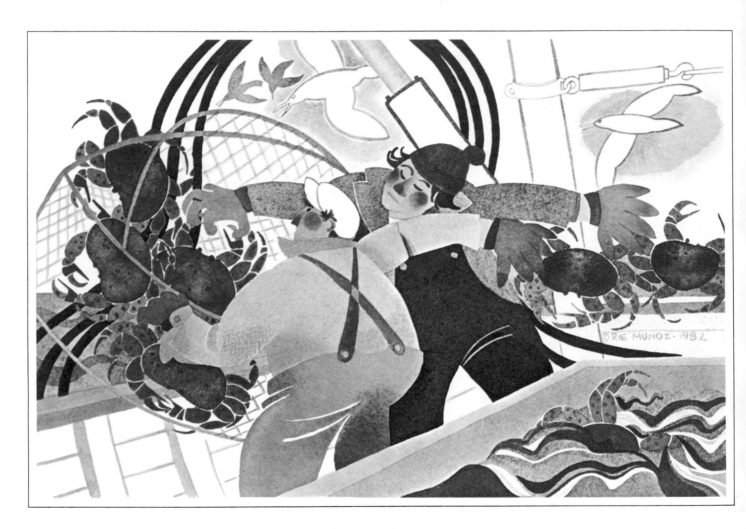

HAULING IN CRABS
1982
13½ by 9 inches
Water base

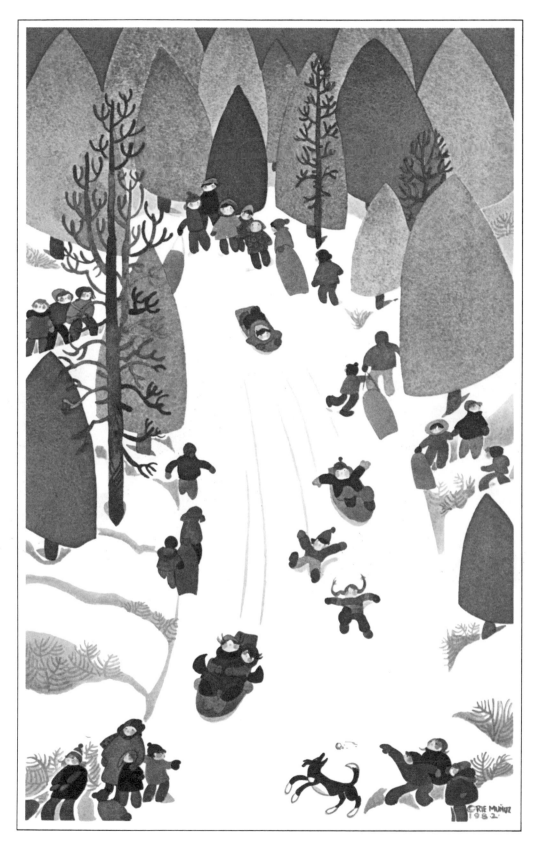

EVERGREEN BOWL
1982
10¼ by 16¾ inches
Water base

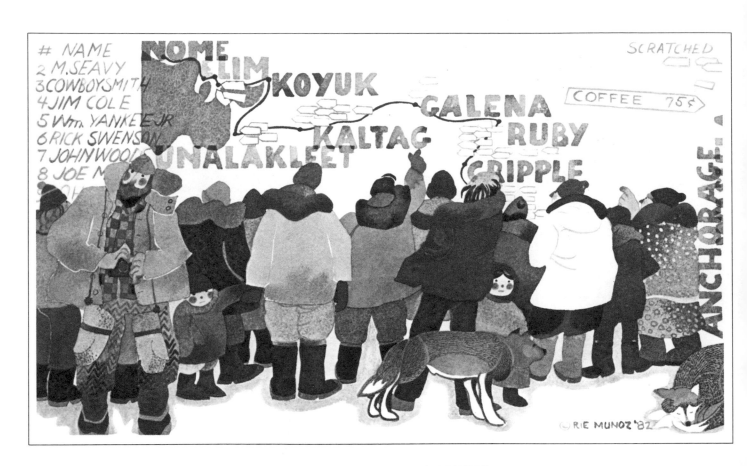

IDITAROD RACE HEADQUARTERS
1982
16 by 9 inches
Water base

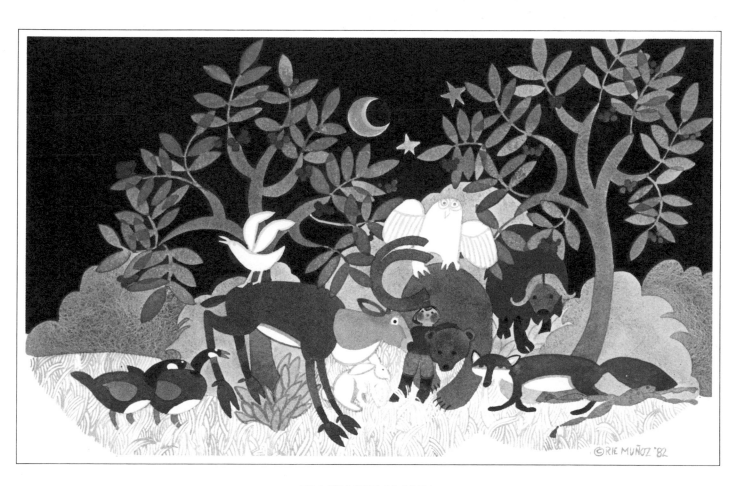

PEACEABLE ALASKA
1982
16 by 11 inches
Water base

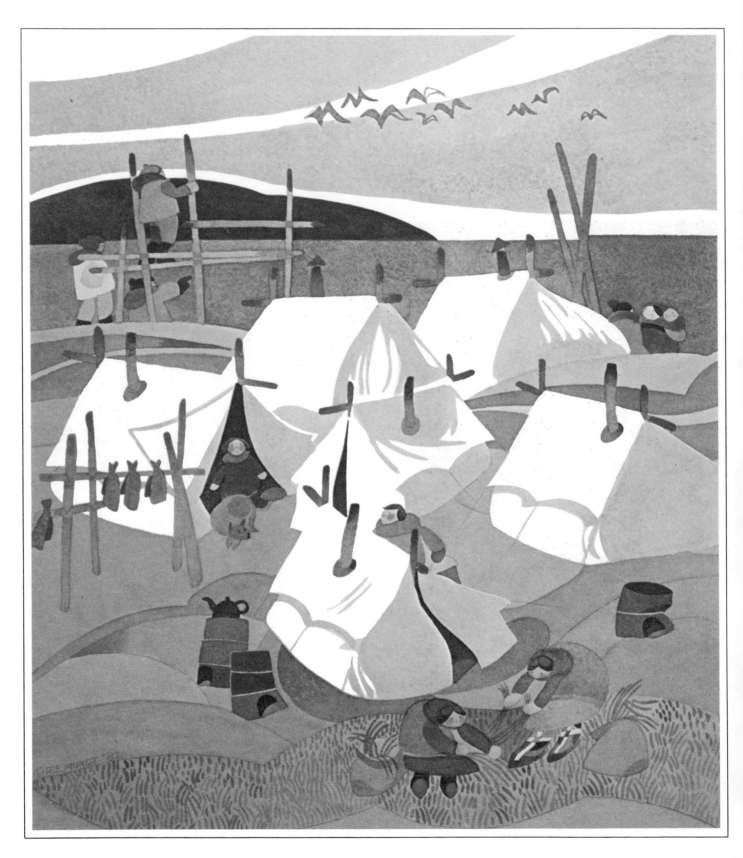

SUMMER CAMP
1982
13 by 15 inches
Water base

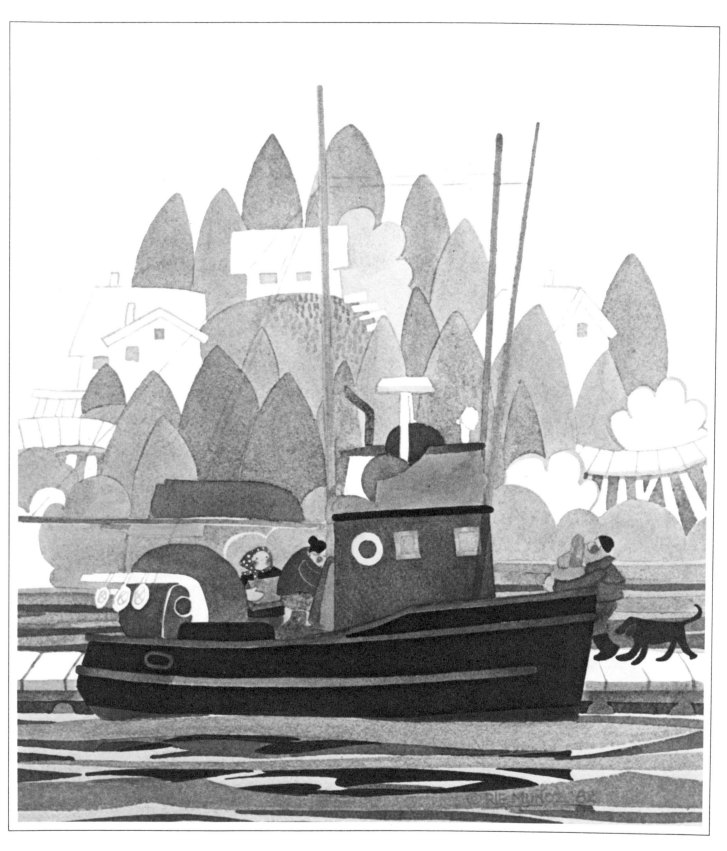

ELFIN COVE
1982
8¾ by 9¼ inches
Water base

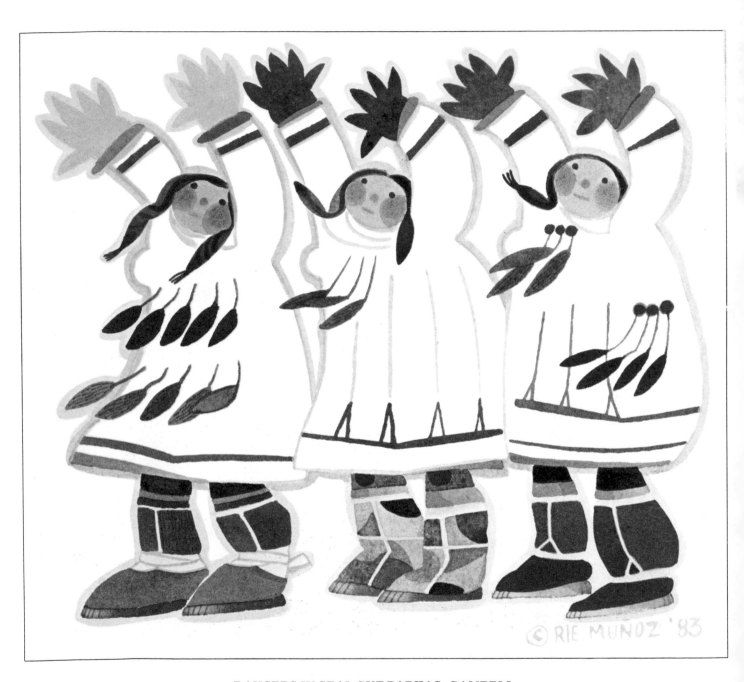

DANCERS IN SEAL GUT PARKAS, GAMBELL
1983
8 by 6¾ inches
Water base

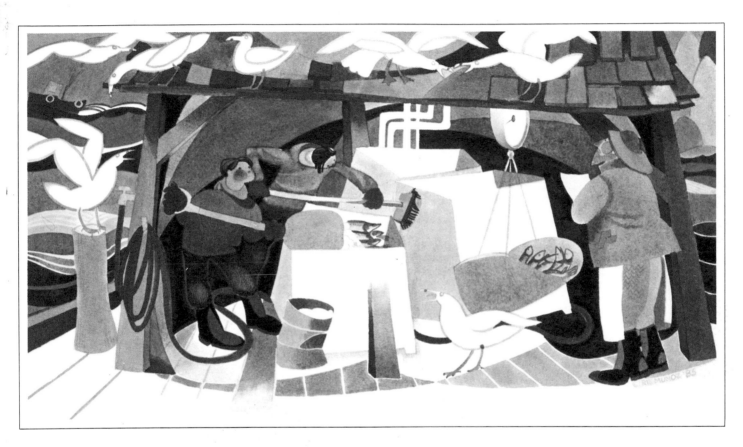

FISH BUYER, ELFIN COVE
1983
15¾ by 8½ inches
Water base

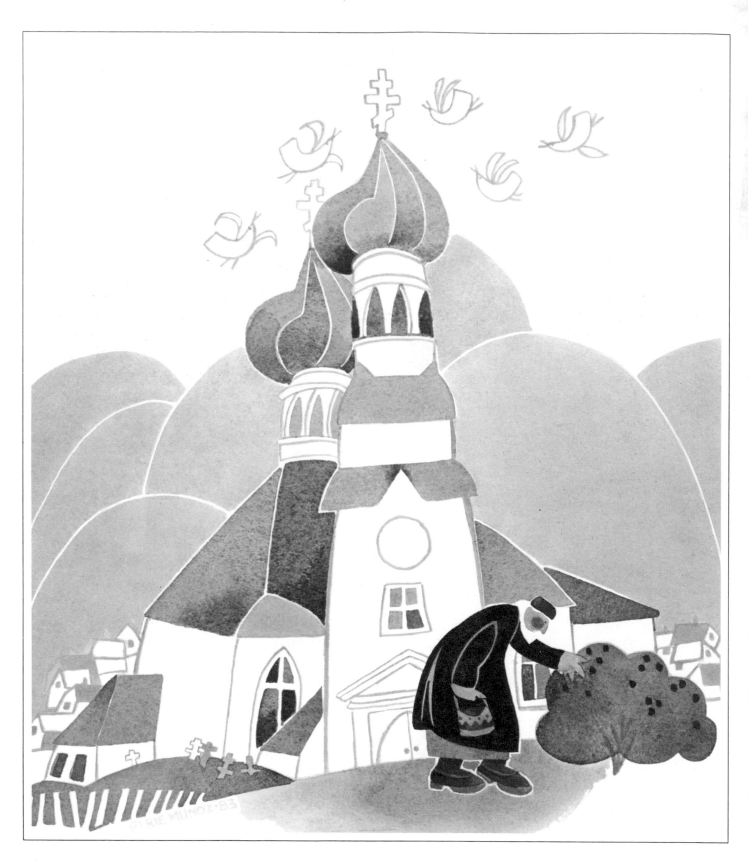

GATHERING WILD RASPBERRIES, UNALASKA
1983
10⅛ by 11½ inches
Water base

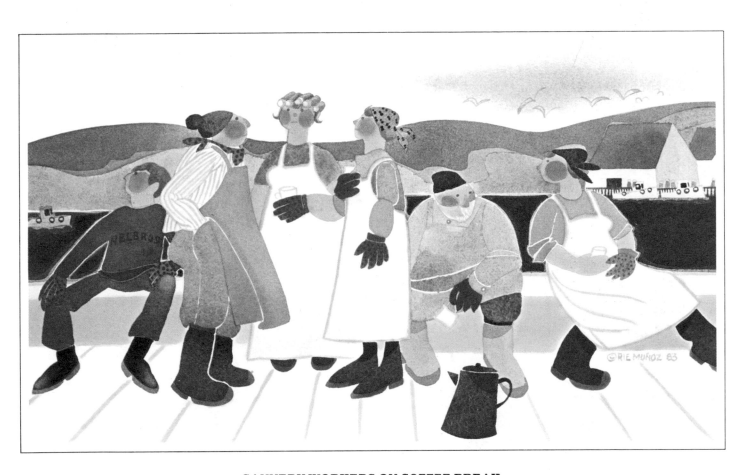

CANNERY WORKERS ON COFFEE BREAK
1983
15½ by 9⅛ inches
Water base

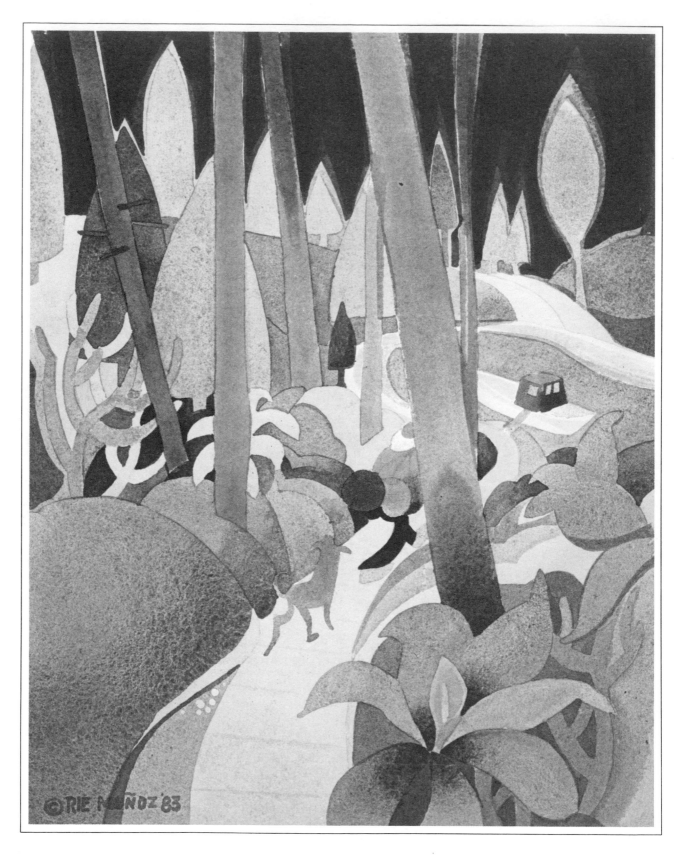

TRAIL THROUGH THE WOODS AT ELFIN COVE
1983
7¾ by 9⅞ inches
Water base

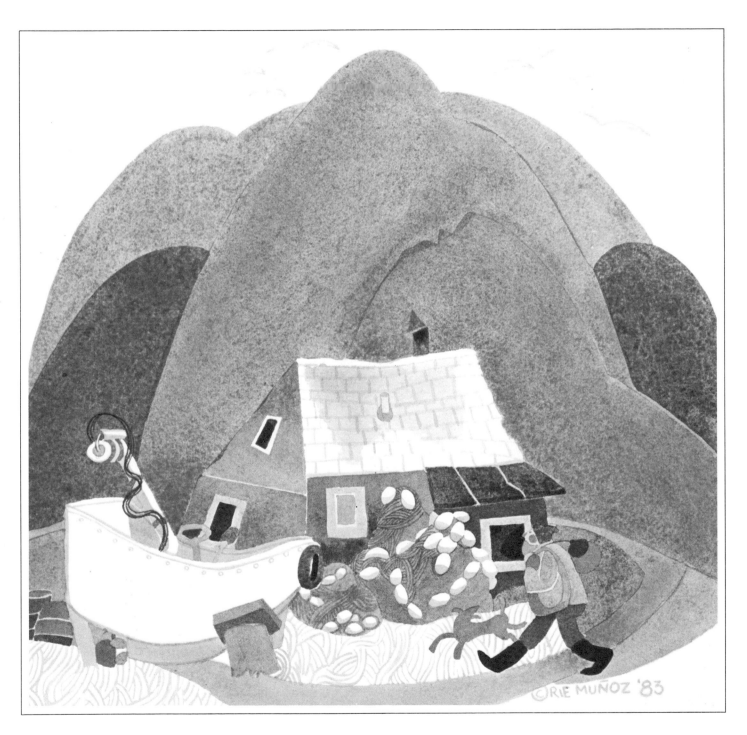

UNALASKA FISHERMAN'S SHACK
1983
9¾ by 9¼ inches
Water base

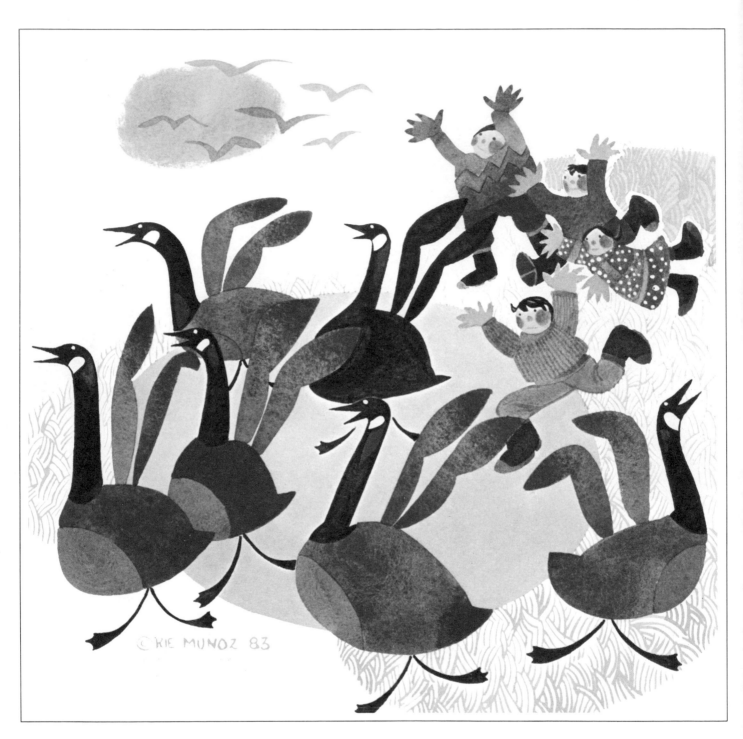

CHASING MOULTING GEESE
1983
9¾ by 9½ inches
Water base

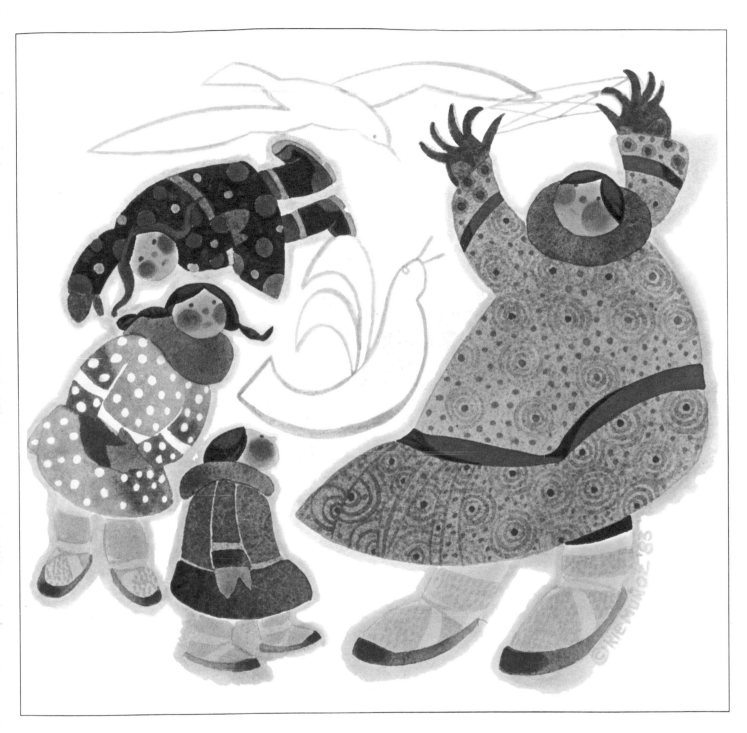

SEAGULL STORY
1983
9⅛ by 8⅜ inches
Water base

DATE DUE

GAYLORD			PRINTED IN U.S.A.